AN HP STORY

THE EVOLVING WAY

THE VALUES THAT SHAPED A COMPANY
SEEDED THE VALLEY
AND CHANGED THE WORLD

TROPE PUBLISHING CO.

THE EVOLVING WAY

What is the spirit of innovation and impact emanating from an otherwise unassuming strip of land south of San Francisco that was once little more than grazing pastures for cattle and the "prune capital of the world"? Why has Silicon Valley come to occupy such an iconic position in the ongoing story of human achievement? What is at the root of the world-changing potential that blossomed there – and spread to all corners of the world?

Much of the story begins with HP and the enduring culture of innovation, entrepreneurship and corporate citizenship that Dave Packard and Bill Hewlett established there. Considering the companies that followed – and the trillions in market capitalization that has been created – you might think that HP's pioneering success in Silicon Valley was little more than the catalyst for a decades-long technology gold rush. But a closer examination of the principles and achievements of the Hewlett-Packard corporation reveal something deeper, and more prescient, about the nature of business and the very definition of success. These are not just seminal stories of the past, but a way to think about the intersection of *value* and *values* moving forward – for HP, for the Valley, for any business that wants growth to unfold from a belief in its people, a commitment to society, and products that contribute more powerfully, to more people, with every decade.

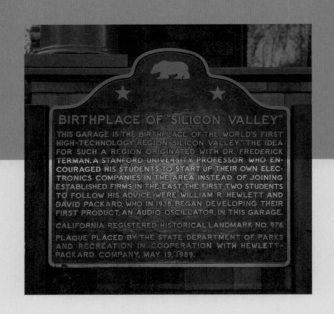

Introduction

It's been more than eight decades since David Packard and Bill Hewlett set up shop in their garage at 367 Addison Avenue in Palo Alto. In that time, much has changed – many times over, in fact. There was the initial propagation of electronics companies that sprung up on the heels of Hewlett-Packard's early success. Then there was the semiconductor boom that first lent the valley between the Santa Cruz Mountains and the Diablo Range its iconic name. The PC and desktop publishing revolution followed in the 1980s and early '90s. The dot-com era exploded onto the scene in 1995. And still the breakthroughs continued: social media in 2004, the sharing economy in 2011. Within these 37 square miles – in appearance unassuming, pastoral, even sleepy – "what's next" always seems just around the corner. Why? What makes it that way?

By the time the phrase "Silicon Valley" first appeared in print in January 1971, HP had been in business for more than 30 years. The company had 16,000 employees, more than 2000 products and 50,000 active customer accounts. They had just realized yearly revenue of more than $350 million and had offices all over the world. For the most part, they were not in the semiconductor business; that was the realm of Shockley, Fairchild, and Intel. Still, if you visit the original HP garage today, you'll see a plaque from the state of California that reads "The Birthplace of Silicon Valley." And it just makes sense. It's not only because of the many iconic products that HP developed over the decades, or the HP alumni that formed dozens of successful companies scattered across the Valley; it's bigger than that. It's a different way of thinking about business and human potential. It's a different way of managing people. It's a different way of integrating the broader interests of society. And it's a way that not only sparked Silicon Valley, but impacted the entire world.

In fact, the "HP Way" has attained a kind of mythological status, not only for the millions of people who have worked at the company, but for anyone familiar with the phenomenal growth and achievements that describe its history. It represents a golden age in Silicon Valley, a time when certain values first guided the development of new ideas, their realization, and their impact on society. Those values are expressed in ways both large and small. Some might reference management whose doors were always open; others might zero in on "management by walking around." Some might point at the early adoption of profit sharing, flextime, and employee healthcare; others might remind us of the incredibly high standards of business performance to which each employee was held. And while the company has since formalized those values and now shares them with new employees, "The Way" at its best is something felt, and not dictated; a set of beliefs and behaviors that flow through the company. Perhaps that's what has always made it so powerful. The best business cultures, after all, are organic and dynamic. They begin with a leader, but are sustained by an evolving, shared sense of the way things are done. In this case, we have a culture sparked not by a single leader, but by two – each remarkable in his own right, but all the more extraordinary for the partnership they formed and maintained for more than 50 years, a partnership that endures in spirit to this very day. You might even say that the fundamentals of the HP Way are grounded in the principles of great partnership: listening, respect, mutual admiration – but also brutal honesty when it's needed, the ability to own mistakes when they are made, and, of course, the generosity to share the fruits of success as it unfolds.

Today's Silicon Valley, with its sprawling campuses and multimillion-dollar mansions may, on the surface, be unrecognizable to the two young men who rented that modest home – and its garage – on Addison Avenue. But if they were to spend some time talking to the talented people who now work there (and they undoubtedly would), they would recognize the same spirit that inspired them to strike out on their own, imagine what could be achieved, and achieve it. And if they were to speak with the managers that work to scale those achievements, they would nod their heads in recognition at certain business practices that build on a fundamental respect for the individual. But they might also hear some unfamiliar things, ideas that emerged from that Silicon Valley ethos but have developed into new ways of tackling the challenges of today and tomorrow. Perhaps those less recognizable ideas, however, would resonate the most, for in them they would sense an evolving way, something that may have started eight decades ago but has morphed to meet the moment, to succeed in ways they could not imagine, and to shine the light forward in ways that only HP can.

01

I GUESS WE JUST FOUND A WAY TO MAKE A BETTER PRODUCT.

David Packard

THE GARAGE

01 The Garage

A Place to Start

The garage: it is an icon of entrepreneurialism that has inspired decades of inventors, innovators and startups – a symbol of a roll-up-the-sleeves, can-do spirit that transforms a face in the crowd into the world-beater, a teenage hacker into a rock star . . . two friends with a shared passion for engineering into founders of a multibillion-dollar corporation.

In the spring and summer of 1938, David Packard was working for General Electric in Schenectady, New York, while Bill Hewlett, a researcher at Stanford, looked for a place they could live and work while they got their company-to-be off the ground. When he found the property at 367 Addison Avenue in Palo Alto, the 12-by-18 freestanding garage was a major draw. As he wrote to Dave:

I was so pleased with it that I rented it right off the bat . . . [I]t was so much better than anything else that we had seen, I did not think it would be wise to wait . . . The garage (the shop) is concrete floored and has a work table in it already."[1]

EXPERIMENTATION, COURAGE AND CONFIDENCE

The garage as innovation space may not be a concept that wholly originated with HP, but it is HP's origin story that sparked our collective imagining of all that is possible there. It is from those beginnings – and the achievements that followed – that so many took, and continue to take, inspiration. From Apple to Amazon to Tesla, and for countless lesser-known startups in every industry, the garage is a place to start efficiently and intelligently, with the passion and creativity so essential to long-term success. The hungry entrepreneur starting a company in their garage is now a totem of mythological status, but Bill and Dave were the blueprint.

Of course, the garage is not only an origin story. It's an idea – about experimentation, courage and confidence that continues to resonate and guide; an idea that HP took forward as it grew, and one that many corporations today seek to kindle in their own cultures and business ambitions.

MODERN RE-CREATIONS OF ONE OF THE GARAGE'S
ORIGINAL WORKBENCHES

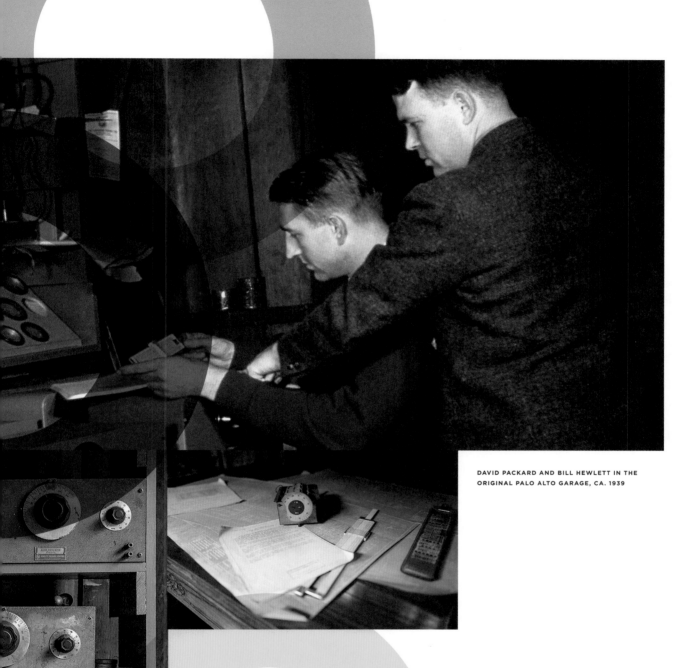

DAVID PACKARD AND BILL HEWLETT IN THE
ORIGINAL PALO ALTO GARAGE, CA. 1939

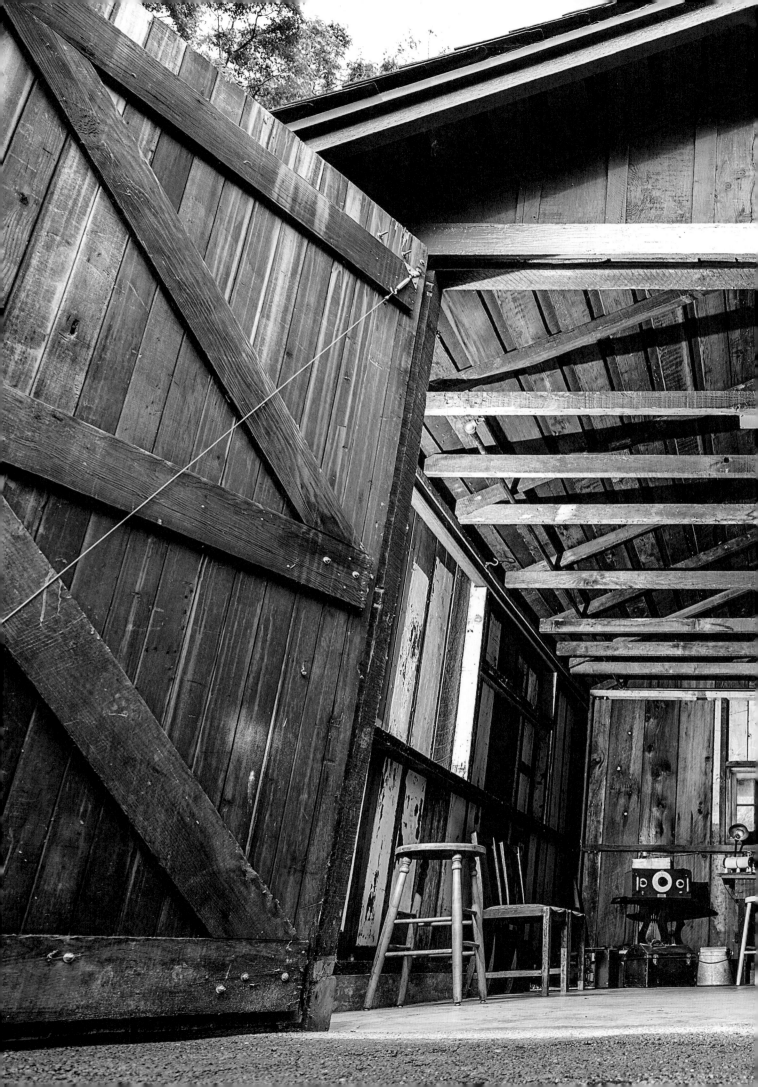

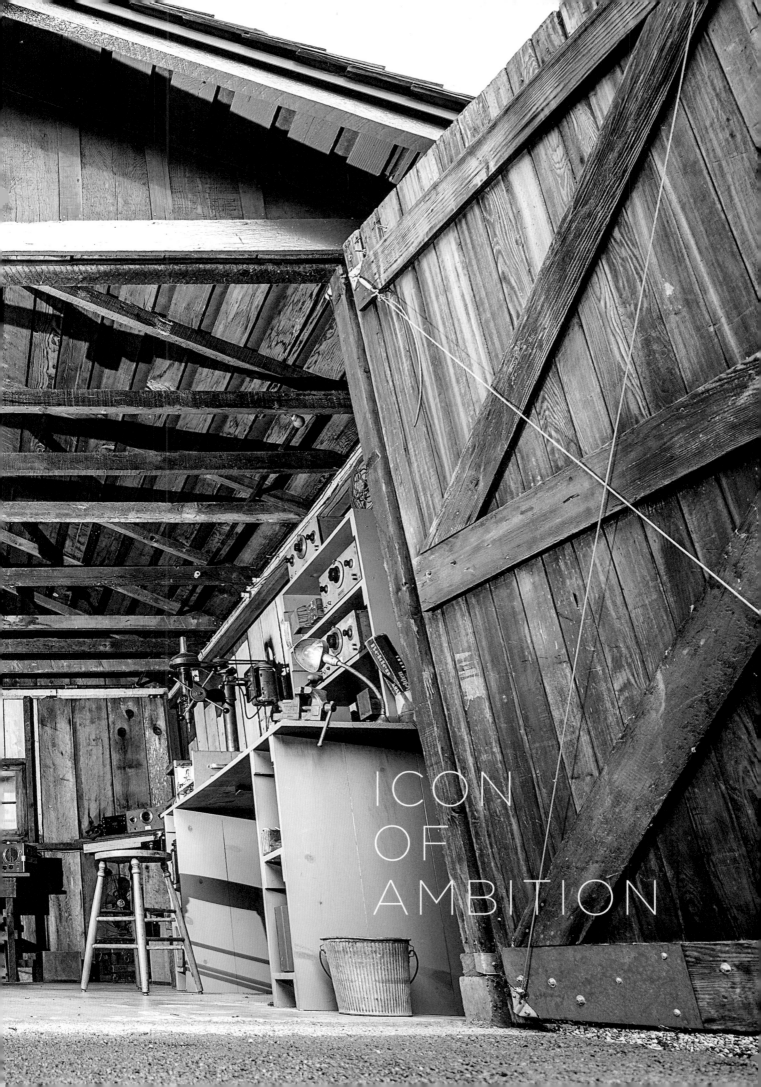

ICON
OF
AMBITION

THE SPIRIT OF INNOVATION

HP's garage ethos has inspired entrepreneurs for decades, both directly and as a result of the spirit of innovation and collegiality it fostered. An entire generation of technologists, some of whom got their first jobs at HP, put those values to work as they started their own companies:

Apple Computer *could arguably be called an HP direct descendant. A 12-year-old Steve Jobs called Bill Hewlett at home to request spare parts for a frequency counter he was building. Hewlett was so impressed with the boy's hustle that he not only sent him the parts, he later gave him his first summer job. Jobs became friends with HP engineer Steve Wozniak, who was working on a mainframe computer, and the two collaborated on a series of side projects for several years. After Wozniak failed to get HP interested in the personal computer prototype he had been building from the company's accessible spare parts, he and Jobs launched Apple in the garage of Jobs' parents' home. (Jobs and especially Wozniak remained affectionate toward HP, and Apple even partnered with HP on a PC-compatible iPod in 2004.)*

In 1975, college dropout Bill Gates and his friend Paul Allen started a company called **"Micro-Soft"** *in a tiny Albuquerque garage and a nearby motel.*

Jeff Bezos, now one of the richest people in the world, started a company named Cadabra in the garage of his rental house in Bellevue, Washington. After hearing a few too many people call his nascent company "Cadaver," he changed its name to **Amazon.** *He later told The Wall Street Journal that he rented the house partly due to that garage, so that he could brag about a company origin like Hewlett-Packard's.*

Larry Page and Sergey Brin rented Susan Wojcicki's Menlo Park garage for space to work out **Google's** *early algorithms and index websites. In quirky Silicon Valley fashion, their initial server was housed in a cabinet built of Lego bricks. And just like HP, Google later purchased that garage in tribute to the company's scrappy roots.*

Tesla Motors *engineer and CTO JB Staubel did some of the early technical development in his own garage.*

Daymond John started and grew **FUBU** *in his mother's Queens garage – not with a desk and a computer, but following the true HP path of production. John packed the Hollis garage with sewing machines and seamstresses making polar fleece items, burning the waste outside (to his neighbors' dismay).*

TESLA MOTORS 2003

AMAZON 1994

APPLE 1976

GOOGLE 1998

MICROSOFT 1975

FUBU 1992

DIRECTLY OR NOT, HP'S GARAGE BEGINNINGS HAVE
INSPIRED ENTREPRENEURS FOR DECADES

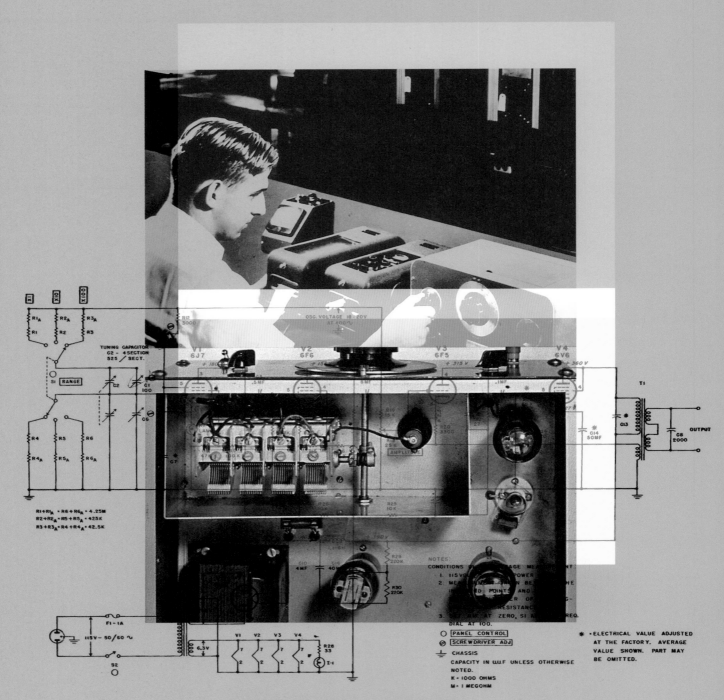

SCHEMATIC DIAGRAM OF MODEL 200A AUDIO OSCILLATOR
SERIAL NO. 30,223 TO

HEWLETT'S DESIGN FOR THE 200A OSCILLATOR WAS
SIMPLE, ELEGANT – AND REVOLUTIONARY

THE SPARK OF AN IDEA

From Prototype to Production

First products: they are often makeshift, bootstrapped, even jury-rigged – spare parts gathered from whatever is at hand, repurposed in ways that may or may not have been originally intended. Each begins with the spark of an idea. It could come from anywhere: a client, an observation on the commute to work, a realization that something simple could be better. In the garage, they come to life through prototypes, testing, iteration. Before there is mass production, there are important failures and experimentation; before there is scale, there is the garage.

It was Bill Hewlett's work at Stanford that sparked what would become HP's first product. While working on a team developing a new electroencephalograph, he solved one of the thorniest problems in building oscillators: getting a signal's resistance to vary in time with the signal itself. His elegant method – using that evergreen symbol of a great idea, a light bulb, to burn off excess power – resulted in an oscillator more accurate than the best ones already on the market, and at a fraction of the price. At 367 Addison, his breakthrough would be refined into the 200A oscillator.

THE PATENT FOR THE 200A WAS THE FIRST OF WHAT IS NOW ONE OF THE WORLD'S LARGEST PATENT PORTFOLIOS – MORE THAN 37,000 WORLDWIDE

3000 Hz

**LOW END OF RADIO
SPECTRUM**

60 Hz

**LONG-DISTANCE POWER
TRANSMISSION LINES**

20 Hz

**BOTTOM OF HUMAN
HEARING RANGE**

400 H

WORLD
POWER

AUDIO OSCILLATO
MODEL 200-A
HEWLETT-PACKARD CO
PALO ALTO

MORE ACCURATE,
MORE AFFORDABLE

10 kHz - 14 kHz

1000 Hz

261.63 Hz

OMEGA NAVIGATION
SYSTEM, PREDECESSOR
OF GPS

AMPLITUDE

OUTPUT

ON

MIDDLE C NOTE

SUBMARINE
COMMUNICATION

MODEL 200A
AUDIO OSCILLATOR

THE 200A OSCILLATOR, NAMED SO THAT CUSTOMERS
WOULDN'T SUSPECT IT WAS THE COMPANY'S FIRST PRODUCT

BORN IN ANN ARBOR, MICHIGAN 1913

FAMILY MOVED TO SAN FRANCISCO 1916

JROTC BATTALION COMMANDER 1929-1930

WILLIAM HEWLETT
STANFORD UNIVERSITY
1934

BACHELOR'S DEGREE FROM STANFORD UNIVERSITY 1934

MASTER OF SCIENCE DEGREE FROM MIT 1936

DEGREE OF ELECTRICAL ENGINEER FROM STANFORD 1939

OFFICER, ARMY SIGNAL CORPS 1942-1945

WHAT HEWLETT ACCOMPLISHED THAT JULY DAY REMAINS ONE OF THE MOST CLEVER BITS OF PRACTICAL INVENTION IN TECHNOLOGY HISTORY.[2]

Michael Malone

Bill & Dave: How Hewlett and Packard Built the World's Greatest Company

At the end of the summer of 1938, Dave and his new wife Lucile drove from New York to California with Hewlett-Packard's first piece of equipment, a used Craftsman drill press, in their car. The newlyweds moved into the first floor of the main house on Addison Avenue, while bachelor Bill settled into the tiny backyard shed – which, unlike the garage, still had a dirt floor.

Work on the 200A began in earnest. By November 1938, they had turned Bill's breakthrough concept into a workable prototype, then a commercial product, with classic garage ingenuity: purchased cabinets and standard radio parts, aluminum panels sawed and drilled, enamel spray-painted and then baked in the Packards' kitchen oven. (Lucile is said to have remarked that the roasts never tasted the same.) The two men also took on contract work, with a range of quirky projects.

"In the beginning we did anything to bring in a nickel. We had a bowling lane foul line indicator. We had a thing that would make a urinal flush automatically as soon as a guy came in front of it."[3]

BILL HEWLETT TO REPORTERS IN 1987

These jobbing contracts not only brought in sorely-needed income; they made the young men more sure of their own skills, and revealed how complementary their abilities were.

CLASSIC GARAGE INGENUITY

THE ENAMEL FOR HP'S FIRST OSCILLATORS WAS
BAKED IN THE KITCHEN STOVE

TOP: 367 ADDISON AVENUE, PALO ALTO. DAVID AND
LUCILE PACKARD RENTED THE FIRST FLOOR, WITH
THEIR LANDLADY IONE SPENCER ON THE SECOND

ABOVE: MODERN RE-CREATION OF HEWLETT'S
BUNKHOUSE LIVING QUARTERS

01 THE GARAGE

LEFT, FLORA AND WILLIAM HEWLETT IN 1960;
ABOVE, LUCILE AND DAVID PACKARD IN 1945

A PARADIGM OF PARTNERSHIP

When David Packard asserted to other business leaders in 1949 that a company had responsibilities to its employees, its customers, and its community, he was all but laughed out of the room. Prevailing management styles were stereotypically "masculine": bureaucracy and managerialism, aggressive pursuit of profit above all else, a rigid, almost militaristic chain of command where orders were passed down and expected to be followed without question.

Packard and Hewlett, however, believed differently. Both men married smart, educated women – Flora Hewlett was a biochemistry major at UC Berkeley, and Lucile Packard a fellow student at Stanford. Lucile and Flora supported the fledgling company in countless ways, not least of all working to keep a paycheck coming into the households. Lucile could even be argued as a third founder of HP; she participated in decision-making, kept the books, interviewed prospective employees. And, in David Packard's own words, "contributed . . . a sense of caring that, eventually, became a vital component of the spirit that defines everything we do."

That caring, that valuing of family and connection, has long been pigeonholed as "feminine." Lucile brought to human resources an innovative way of thinking about how employees should be treated, and by weaving threads of connection throughout its management philosophy, HP emerged as a hybrid ahead of its time, a company that brought together both ends of the managerial spectrum and created something new.

Demand performance **and** safeguard employees' well-being; contribute to the community **and** deliver profits; respect the individual **and** emphasize teamwork. Management by shared goals, not management by control. The HP Way is predicated on this balance, on setting high standards and then supplying the tools needed to reach them.

"This revolution in labor and management attitudes is at least one example of social progress which is as important as some of the scientific progress which has been achieved . . . "

DAVID PACKARD, COLORADO COLLEGE COMMENCEMENT SPEECH, 1964

WHAT HAPPENED NEXT IS HP AND SILICON VALLEY LORE.

The 200A attracted attention from Bud Hawkins, chief sound engineer at Walt Disney Studios, when he learned that it cost a fraction of the machines he was planning to purchase for the upcoming *Fantasia*. Hawkins requested a number of modifications, resulting in the 200B model, then purchased eight of them. Hewlett-Packard had its first "volume" sale. Variations on the oscillator's basic circuitry made up HP's first product line, and with modifications over time, models in the 200 line would be manufactured by HP for nearly 50 years.[4]

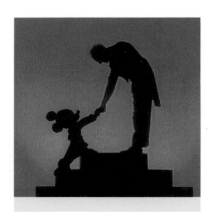

MICKEY MOUSE CONGRATULATES LEOPOLD STOKOWSKI
FOR CONDUCTING "THE SORCERER'S APPRENTICE"

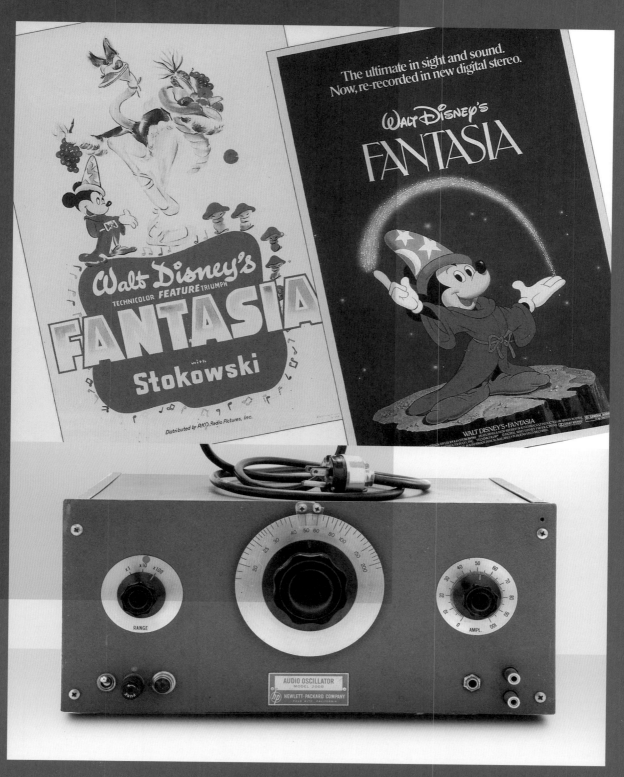

MODEL 200B EVOLVED FROM THE 200A AS A RESULT
OF DISNEY'S REQUESTED CHANGES

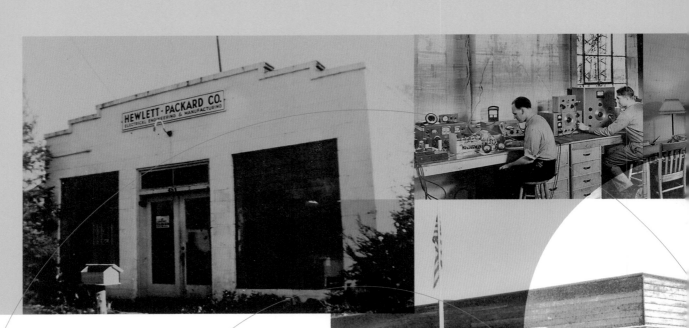

HP'S SECOND LOCATION, 481 PAGE MILL ROAD,
KNOWN AS THE "TINKER BELL" BUILDING

395 PAGE MILL ROAD, THE FIRST BUILDING BUILT
AND OWNED BY HP

OPEN-DOOR
AND COLLABORATIVE
CULTURE

In 1939, Dave and Bill added their first payrolled employee, Harvey Zeiber. Close quarters mandated good communication in order to succeed, laying the groundwork for the open-door policy and resistance to strict hierarchy that would become hallmarks of the HP Way. Still, things quickly got a little too cramped at 367 Addison. By the end of 1940, HP had left the garage for a rented building about two miles away at 481 Page Mill Road. In 1942 they began construction of the first company-owned building.

SPACES BUILT FOR TEAMWORK

THE SOLUTIONS THEATER IN THE HP CUSTOMER
WELCOME CENTER IN PALO ALTO

TOP, THE LOBBY OF THE HP CUSTOMER WELCOME CENTER IN PALO ALTO;
BOTTOM, HP'S 3D CENTER OF EXCELLENCE IN BARCELONA

THE SPIRIT OF
INGENUITY

Rules of the Garage

Skip forward to 1999. New HP CEO Carly Fiorina codified the "Rules of the Garage" in a memo to HP general managers that turned into a worldwide advertising campaign.

In reframing some fundamental tenets of the HP Way, she recognized the persistence of the garage spirit that originated at 367 Addison – and how crucial it had been to the ongoing growth and health of the company. In the 60 preceding years, and in the 20+ years that have followed, that spirit has been confirmed over and over again, never so much as when an urgent need emerged – a problem to be solved, something new that had never been done before.

In the 1940s and '50s just such a need arose around microwave technology. The company was growing by leaps and bounds during World War II, due largely to the US government's pressing equipment needs. HP landed engineering and manufacturing contracts for products developed at MIT and Harvard Labs:

"The word was all around the [Stanford] labs that HP put out excellent equipment and that Dave Packard was a wonderful fellow to work with. All that reputation was established that early."[5]

FRANK CAVIER, HP VICE PRESIDENT / EMPLOYED FROM 1942-1976

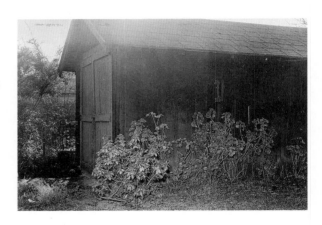

THE GARAGE AT 367 ADDISON AVENUE
WAS ADDED TO THE NATIONAL REGISTER
OF HISTORIC PLACES IN 2007, A SYMBOL
OF THE GARAGE ETHOS EVERYWHERE

BELIEVE YOU CAN CHANGE
THE WORLD.

WORK QUICKLY, KEEP THE
TOOLS UNLOCKED, WORK
WHENEVER.

KNOW WHEN TO WORK ALONE
AND WHEN TO WORK TOGETHER.

SHARE TOOLS, IDEAS. TRUST
YOUR COLLEAGUES.

NO POLITICS. NO BUREAUCRACY.
(THESE ARE RIDICULOUS IN
A GARAGE.)

THE CUSTOMER DEFINES A JOB
WELL DONE.

RADICAL IDEAS ARE NOT
BAD IDEAS.

INVENT DIFFERENT WAYS OF
WORKING.

MAKE A CONTRIBUTION EVERY
DAY. IF IT DOESN'T CONTRIBUTE,
IT DOESN'T LEAVE THE GARAGE.

BELIEVE THAT TOGETHER WE
CAN DO ANYTHING.

INVENT.

CAN-DO SPIRIT AND PASSION TO CHANGE THE WORLD

Connections at the Naval Research Laboratory had developed a microwave signal generator and were looking for a production partner. Despite having no experience with microwave frequency, HP worked around their limited machining capabilities and fulfilled the contract. Impressed, the lab began working with them on additional instruments, culminating in a device to disrupt an enemy's shipboard radar. Dubbed "the Leopard project," it was both a key contribution to the war effort and a stake planted for HP as a leader in the budding industry for microwave technology.

That can-do spirit and passion to change the world was needed again in the 1960s and '70s, in support of humankind's boldest-ever engineering challenge. Getting a man to the moon would require technology that had hardly been dreamed of, let alone invented, and HP worked closely with NASA and other technology companies to make it happen. By the time of the Apollo 11 landing, no less than 20 different HP products had been developed, modified, or mobilized for the effort, from monitoring astronauts' heart rates to relaying information in real time from space back to Mission Control.

ART FONG, HP'S "FATHER OF MICROWAVE," CONDUCTS A RADAR TEST IN 1947

THE SANBORN 350 TAKING BASE RECORDINGS OF
ASTRONAUT GORDON COOPER PRIOR TO HIS FLIGHT

MERCURY PROJECT

1963

hp

THE DAWN OF THE PERSONAL COMPUTER

The dawn of the personal computer was yet another turning point – for the world and for HP. In many ways, HP started the 1980s as one kind of company – one focused on enterprise – and ended the decade well on its way to its current status as a dominant player in consumer electronics. To get there, however, would require a string of products – some more successful than others – that demonstrated a willingness to iterate and learn, in-market and side-by-side with customers.

The HP-85, the company's first personal computer, was an early recognition of the eventual direction of the market when it launched in January 1980. While it may seem bulky and awkward now in the age of ever-sleeker laptops, the HP-85 was designed to be portable, with the display, keyboard and printer an integrated unit that fit into a carrying case. It was quickly followed by the HP-75C, their first handheld personal computer.

It was the HP-150, however, that was a watershed achievement: the first HP machine to run MS-DOS, one of the first commercial machines to use 3.5" disks, among the earliest personal devices featuring a touchscreen. HP built much of their early consumer-focused infrastructure atop the 150; the year it came out, the company quadrupled its PC advertising budget and featured a specific product in a TV commercial for the first time. Retailing required a very different strategy than scientific instruments, and HP began building a robust dealer program that laid the groundwork for decades to come.

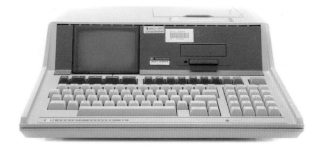

THE HP-85, CONSIDERED THE COMPANY'S FIRST PERSONAL COMPUTER

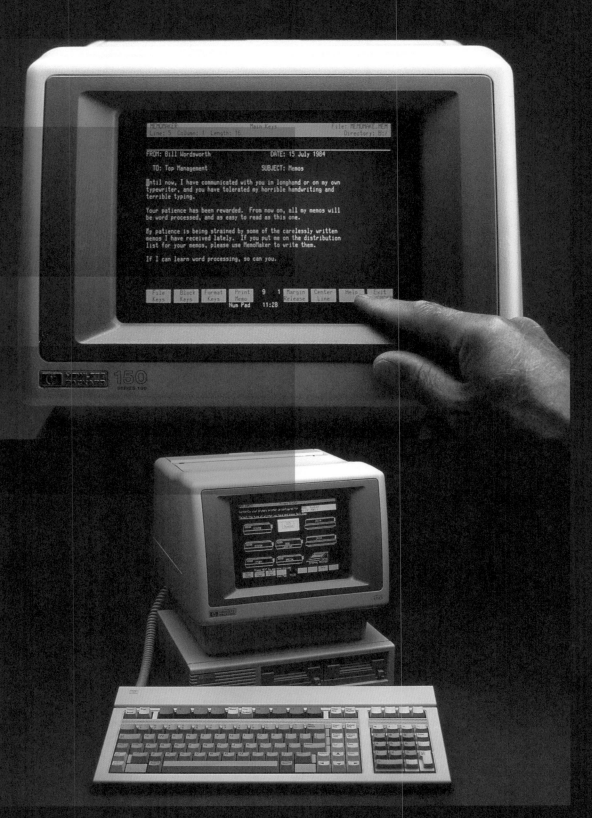

THE HP-150 WAS THE CORNERSTONE OF A NEW
CONSUMER-FACING STRATEGY

THE DESKJET 500C REDEFINED THE MARKET FOR
COLOR PRINTING

THE OFFICEJET PACKED AN ENTIRE OFFICE'S
WORTH OF MACHINES INTO ONE COMPACT UNIT

THE 1990S AND 2000S WERE, IN MANY WAYS, PEAK GARAGE.

With the advent of web browsers and widening access to capital, the barriers to entry were lowered for starting a company. Stories of people quitting their jobs to strike out on their own were common. The garage spirit pervaded the Information Age, spawning companies like eBay, Netscape, Flickr, and Facebook.

HP responded in kind by continuing to democratize how information is handled, building on their success with the original DeskJet and LaserJet models. Printers were engineered to be smaller and cheaper, but with more features; the 1990s saw the debut of both the DeskJet 500C, finally making color printing an affordable option for consumers, and the first OfficeJet product, combining multiple solutions into one compact unit.

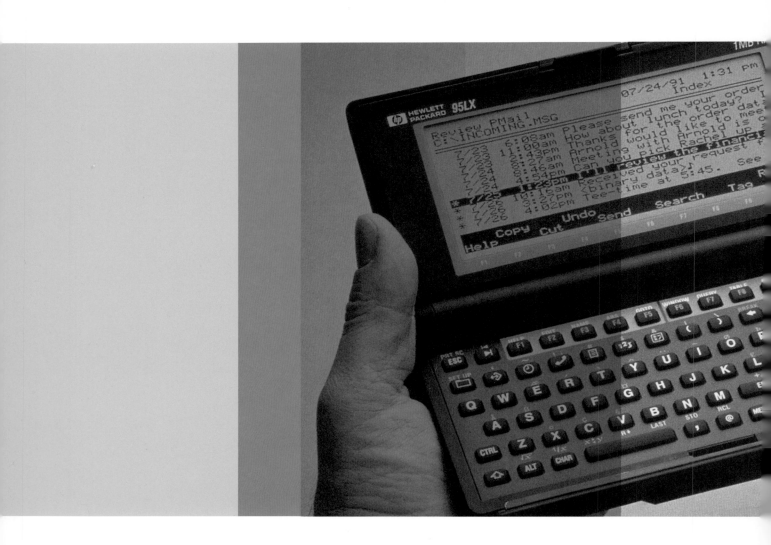

MORE PROCESSING POWER IN SMALLER PACKAGES

The introduction of the Pavilion line, designed and priced for the home computing market, helped put more processing power into homes – and garages – than ever before. Computers continued to shrink; starting with the 95LX palmtop computer, HP worked to set new standards for what pocket-sized machines could do. The 320LX, one of the first palmtops to run Microsoft Windows, and the cooperative work the company did with Palm, Inc., on wireless syncing to PCs foreshadowed the smartphone revolution just over the horizon.

THE 320LX AND 95LX TOOK THE OFFICE ON THE ROAD

CIIRC RP95-3D
FACE MASK

3D PRINTED PPE MASK BODY WITH EXTERNAL FILTER

IN THE GARAGE, RAPID RESPONSE IS MADE POSSIBLE THROUGH INGENUITY AND DEDICATION.

The urgent challenges of today require the invention of new technologies and the deployment of existing ones in entirely new ways. In response to the COVID-19 pandemic, HP mobilized its 3D printing capabilities to design and produce essential parts for ventilators, breathing filters, and door handle adapters, promising to make design files available so they could be produced anywhere in the world. Environmental concerns drive HP's innovations in closed-loop ink cartridge recycling, carbon-neutral home printing, and incorporating recycled plastics and aluminum in the world's most sustainable collection of PCs.[6]

3D PRINTED SWAB FOR COVID-19 TESTING

THE CHARACTER OF A COMPANY TOMORROW IS DETERMINED BY THE PRODUCT IT IS DEVELOPING TODAY.[7]

DAVID PACKARD

HP's ongoing work in 3D printing solutions is helping to drive cutting-edge work in a wide variety of fields: bioprinting and customized prosthetics in the medical field, mass customization for auto manufacturers, and supply-chain and prototyping challenges across industries.

"The key to innovation is understanding customers, pushing technology to the limit, and generating new imaginative solutions."[8]

HP CEO ENRIQUE LORES

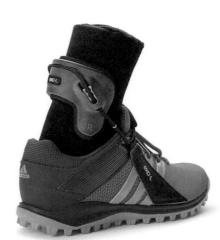

ANKLE BRACE PRINTED BY ZIGGZAGG WITH
THE HP JET FUSION 4200 3D PRINTER

3D CAR BUMPER
AUTOMOTIVE MANUFACTURING

PRINTED WITH THE HP JET FUSION 5200 3D PRINTER
AND HP 3D HIGH REUSABILITY PA 12

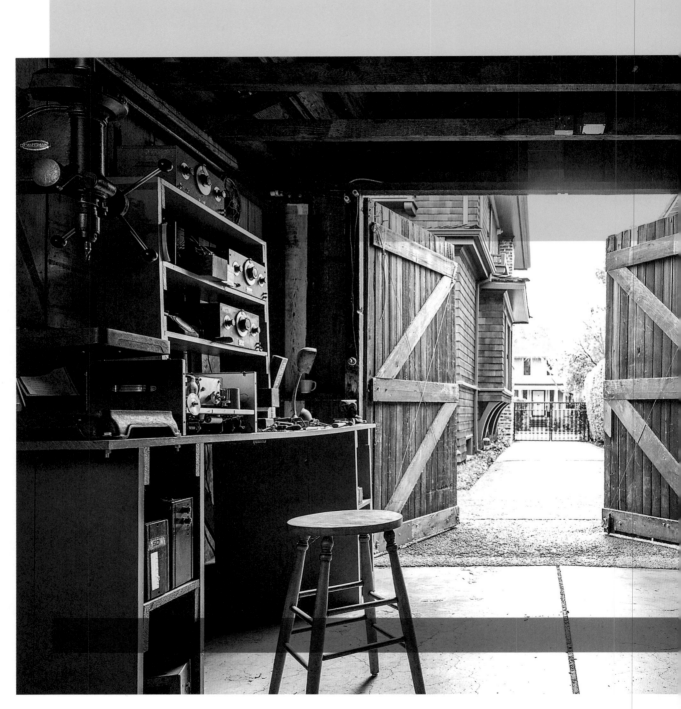

THE HP GARAGE CONTINUES TO INSPIRE INNOVATORS
AROUND THE WORLD

YESTERDAY, TODAY AND TOMORROW

The Garage Effect

An unassuming 12-by-18 freestanding garage on a tree-lined street in Palo Alto: HP was only there for about two years, and the products made there have long since passed into obsolescence. So what makes it resonate still? Some say it was the birthplace of Silicon Valley. Others see a heroic business story – of small beginnings growing into a global enterprise. What underlies both? Human ingenuity, problem solving, the confidence to set up shop and build a business by building solutions for the world. For HP, for those inspired by HP – that is the garage of yesterday, today and tomorrow.

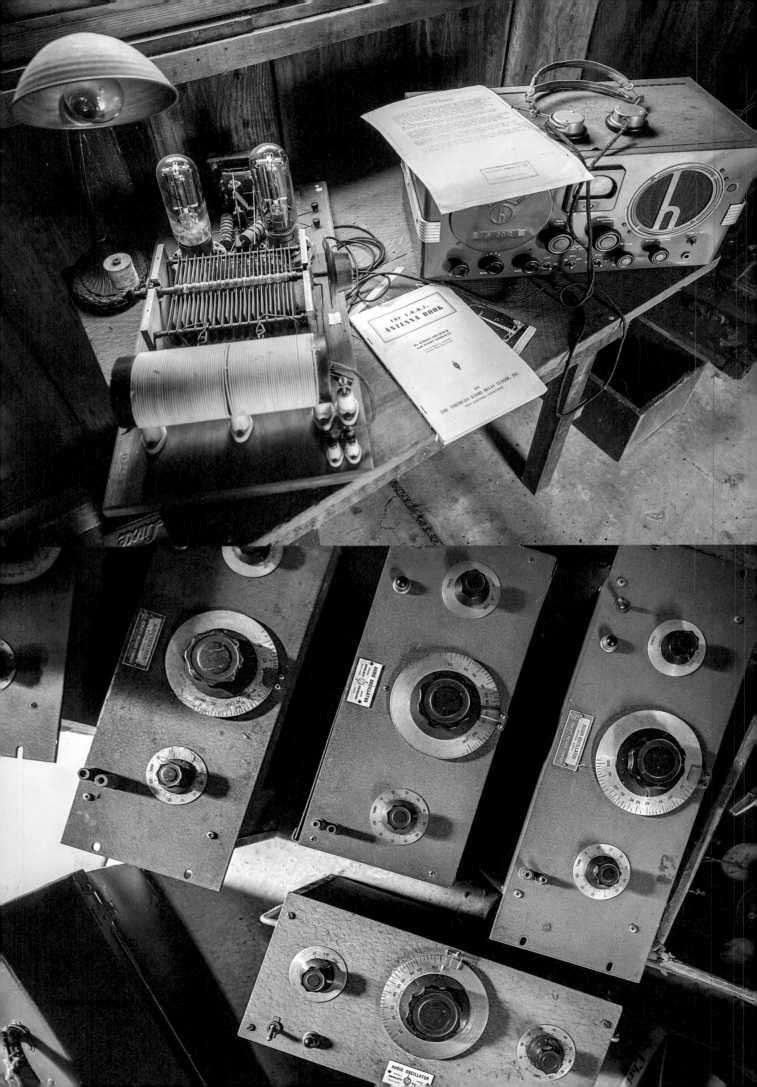

01 THE GARAGE

THE HP GARAGE TODAY, PRESERVED AS BOTH
HERITAGE AND INSPIRATION

THE GARAGE IS NOT ONLY AN ORIGIN STORY.
IT'S AN IDEA – ABOUT EXPERIMENTATION,
COURAGE AND CONFIDENCE.

200B OSCILLATORS FROZEN IN TIME AT THE
ORIGINAL PALO ALTO GARAGE

BIRTHP

THIS GARAG
HIGH-TECH
FOR SUCH A
TERMAN, A S
COURAGED
TRONICS CO
ESTABLISHED
TO FOLLOW
DAVID PACK
FIRST PRODU

CALIFORNIA

PLAQUE PLA
AND RECRE
PACKARD C

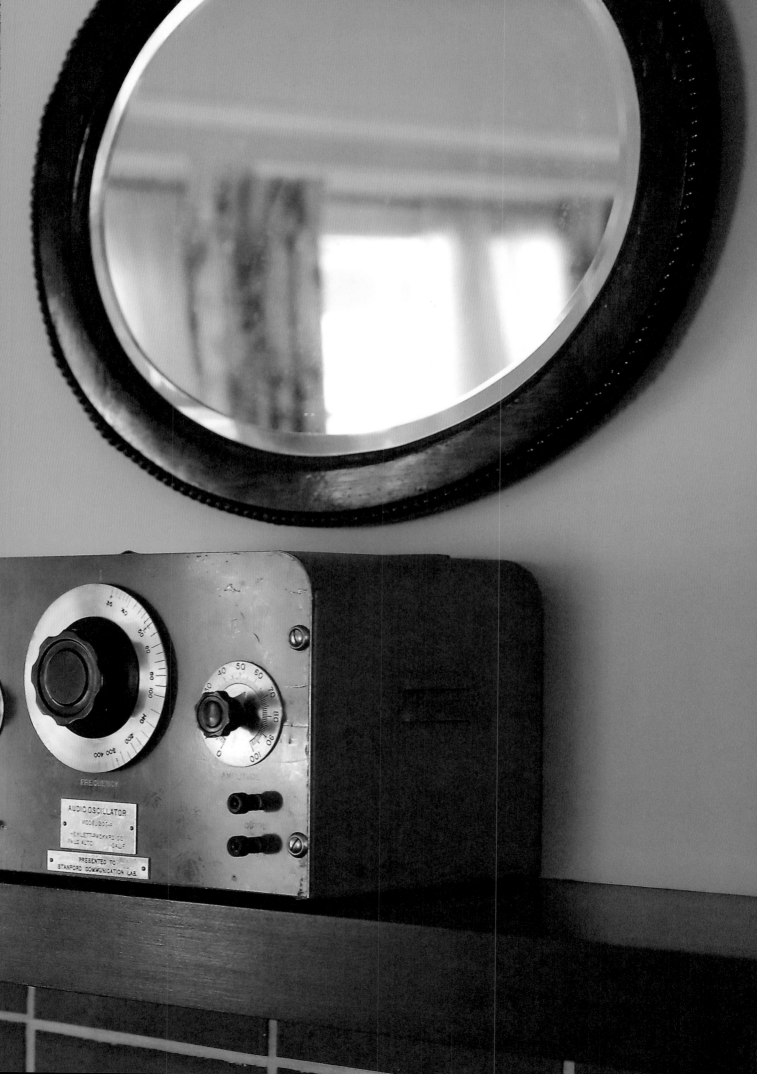

IF THE IDEA FOR A NEW INSTRUMENT APPEALED TO THE HP ENGINEER WORKING AT THE NEXT BENCH, IT WOULD VERY LIKELY APPEAL TO OUR CUSTOMERS AS WELL.

David Packard

THE NEXT BENCH

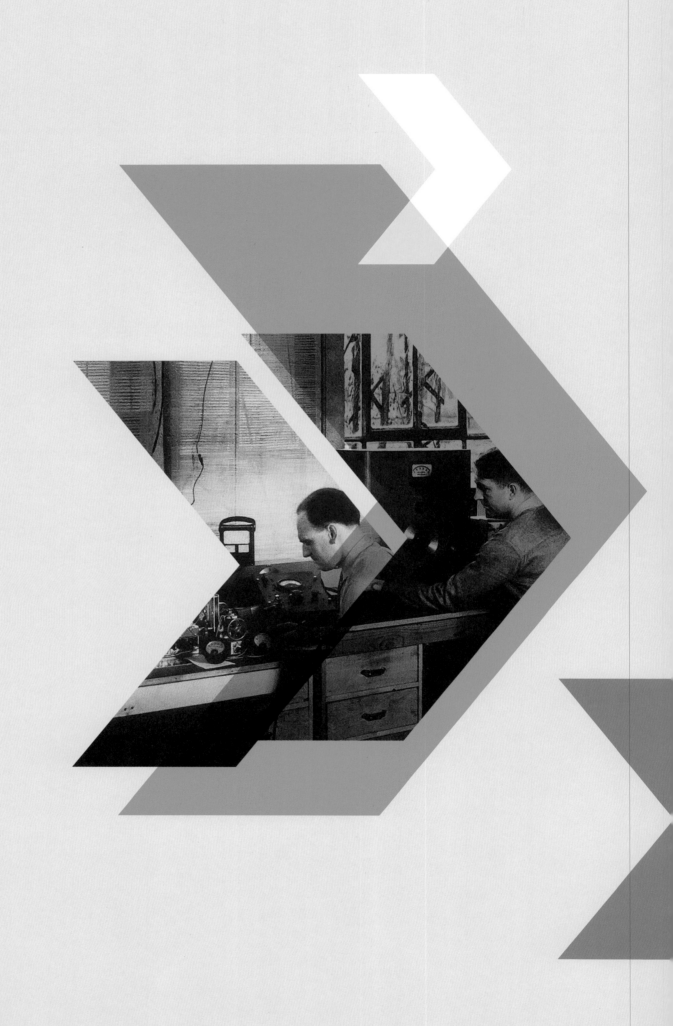

02 The Next Bench

A Different Kind of Listening

"When HP was making primarily test and measuring instruments for engineers, we had a built-in method for helping us determine what customers might need in the way of innovative new instruments. We called it the 'next bench' syndrome. If the idea of a new instrument appealed to the engineer working at the next bench, it would very likely appeal to our customers as well."[9]

David Packard, The HP Way

From its earliest days, HP pioneered and perfected a different kind of listening: an empathy and respect for colleagues and customers that infused every product with an integrity that became deeply associated with everything HP produced. From that imperative emerged breakout products that often flew in the face of conventional wisdom, delivering on an intuitive sense of what was needed and relying upon a kind of chain reaction – from bench to bench – as a testing mechanism for the resonance and relevance of new ideas. Often wildly successful, sometimes not, the resulting products were nevertheless always a reflection of what was to come, and a progenitor of human centered design principles that today are at the heart of best-in-class products and software.

AN EXPRESSION OF THE HP WAY

IN MANY WAYS, THE NEXT BENCH PHENOMENON
WAS A SYNTHESIS OF HP'S MOST DEEPLY HELD
BELIEFS ABOUT PEOPLE; PRINCIPLES THAT
WERE CODIFIED IN VARIOUS VERSIONS OF THE
HP WAY OVER THE DECADES.

**A VERSION DEVELOPED BY HP MANAGEMENT
IN THE 1970S DESCRIBED THEM AS:**

BELIEF IN PEOPLE; FREEDOM

RESPECT AND DIGNITY;
INDIVIDUAL SELF-ESTEEM

RECOGNITION; SENSE OF
ACHIEVEMENT; PARTICIPATION

SECURITY; PERMANENCE;
DEVELOPMENT OF PEOPLE

INSURANCE; PERSONAL
WORRY PROTECTION

SHARE BENEFITS AND
RESPONSIBILITY;
HELP EACH OTHER

MANAGEMENT BY OBJECTIVES;
DECENTRALIZATION

INFORMALITY; FIRST NAME;
OPEN COMMUNICATION

A CHANCE TO LEARN BY
MAKING MISTAKES

TRAINING AND EDUCATION;
COUNSELING

PERFORMANCE AND
ENTHUSIASM

hp

In practice, many of these principles were most tangibly demonstrated in the sharing and testing of ideas at play between employees every day. That kind of collaboration began in the early years of HP and persists to this day – sometimes at a bench, sometimes in a hallway, sometimes on a video call, sometimes around a pot of coffee.

The genesis of the next bench phenomenon, of course, was largely a function of the way the early engineers collaborated and shared ideas about the testing of the very measurement equipment they were designing; engineers developing tools for engineers.

"Not only did every design engineer use HP test equipment EVERY DAY, but they also lived next to other groups who were doing similar but adjacent measurements . . . People did not hold their research protectively. So, measurement improvement became a challenge to each engineer. Almost a team-bragging-rights thing. They could see where productivity improvements in measurements would enhance their day, and strived to make such improvements in their next product. An HP product team that produced an industry breakthrough got the same kind of internal management recognition as a winning sports team . . . In all areas of the shops and lab facilities, one would find clever inventions which made some process or another more efficient or safe or speedy or better."[10]

JOHN MINCK, HP MARKETING 1958–1995

The next bench phenomenon would manifest in a variety of ways as time went on, but at its simplest, an HP engineer would create a device or component that would help or intrigue the guy at the next workbench. Together, they would stumble across a new product.

One of the most famous examples of this dynamic came straight from the top. After HP released the landmark 9100A programmable calculator in 1968, Bill Hewlett announced that he wanted the next calculator to be something he could carry in his shirt pocket, at "a tenth the cost, a tenth the size, and . . . ten times faster."[11]

At the time, developing such a device seemed cost prohibitive, relative to anticipated demand and pricing. When the designer of the 9100A told Hewlett that he finally thought it was possible, Hewlett committed fully to the product's development, seeing the potential where others did not – it was exactly what the engineer in him wanted, and he knew others would, too.

THE 9100A PROGRAMMABLE DESKTOP CALCULATOR

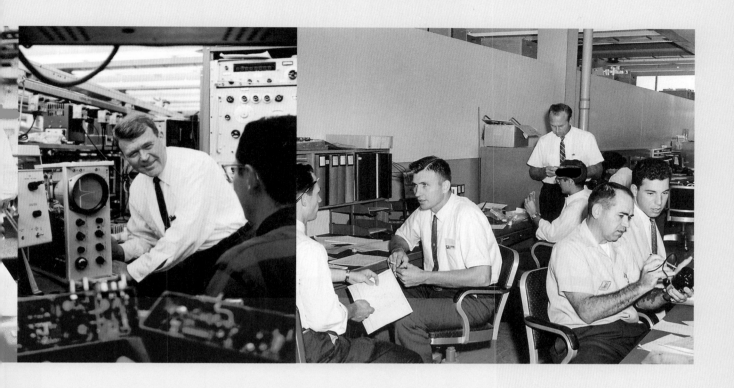

HEWLETT WAS THE EPITOME OF THE NEXT BENCH ENGINEER. AND IF THE NEXT BENCH ENGINEER WANTED SOMETHING, YOU KNEW IT WAS GOING TO BE SUCCESSFUL.[12]

DAVID COCHRAN, HP ENGINEERING 1956–1981

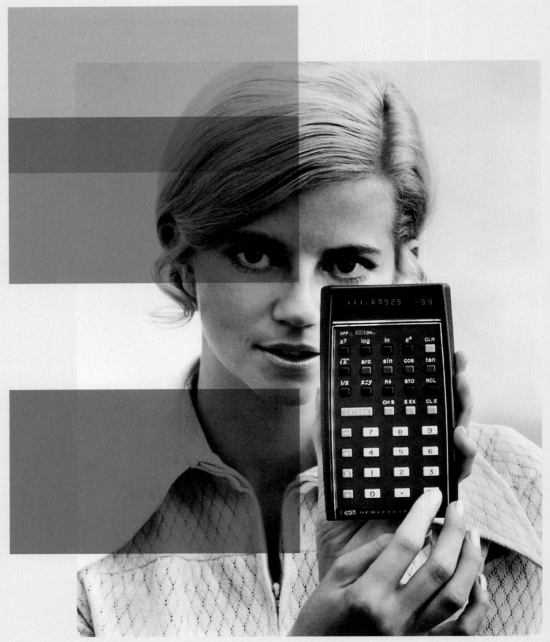

HP-35
SCIENTIFIC CALCULATOR

THE HP-35 WAS THE FIRST HEWLETT-PACKARD PRODUCT
TO BE SOLD PRIMARILY BY DIRECT MAIL

THE WORLD'S FIRST POCKET-SIZED SCIENTIFIC CALCULATOR

The HP-35, released in 1972 and named for the number of keys it contained, was the world's first pocket-sized scientific calculator. Prior to its release, HP Labs head Barney Oliver sent samples to several prominent engineers and physicists – a figurative next bench. The tiny powerhouse attracted so much attention when they showed it off at meetings that HP could not meet the initial demand, which far outstripped even their optimistic projections.

A major technical achievement, the HP-35 made the slide rule – the analog standard for engineering and science calculations since the 17th century – obsolete, practically overnight. It was also a tremendous financial success and marked the company's first major involvement in the consumer retail market, a cornerstone moment as the company moved further towards mass-market electronics in future years.

The Next Bench Principle Reinterpreted

As a manifestation of HP's core values, the next bench phenomenon not only inspired HP's culture of innovation for decades to come; it was also a forerunner of software engineering methods – particularly internal testing – that emerged in the latter part of the 20th century.

In 1980, Apple president Michael Scott issued what is perhaps the most famous memo concerning internal testing:

"Effective Immediately! No more typewriters are to be purchased, leased etc., etc. Apple is an innovative company. We must believe and lead in all areas. If word processing is so neat, then let's all use it! . . . We believe the typewriter is obsolete. Let's prove it inside before we try and convince our customers."

While the term "dogfooding" may or may not have existed before a Microsoft executive remarked in a 1988 email that "We are going to have to eat our own dogfood and test the product ourselves," the idea was already in play. Less than two years after the Scott memo, one executive told *Inc.* that Apple had become "the most computerized company in the world," even by the high-tech standards of 1981 Silicon Valley.

There is intense debate, as technology continues to evolve in sophistication and segment into niches, whether mandated internal use continues to be a valuable testing tactic. Some contend that onboarding is key to good user experience, and employees as company testers have insight and access to help that uninitiated users will not. Critics point out that employee testers have more motivation to overcome friction points, so may not be as sensitive to areas that might derail a more casual user. They argue that there is no replacement for outside UX testing if a company really wants customer feedback.

There is no argument, however, that internal testing is faster, more convenient, and cheaper. It can be a key step in getting all hands working on a project to align their expectations. And it conveys irreplaceable insight when convincing others a product is worth a shot.

AN EXPERIMENT ON THE GLOBAL STAGE

Scaling Collaboration –
The Next Bench in Orbit

As HP grew, the extension of the next bench was inevitable. The ambitions of the employees and the thrill of experimentation on the global stage were irresistible and the permission to listen, experiment, and learn was extended well beyond the confines of the engineer's bench.

When HP Labs was created by combining the company's Electronics Research, Physical Electronics, and Solid State Labs in 1966, it laid the groundwork for a profound scaling of the next bench phenomenon. By mixing together engineers with different specialties and freeing them from the day-to-day business . . .

" . . . the hope was that each lab might broaden its own focus, and moreover, that synergy might result from the combination. It took awhile for cross-pollination to occur, but it didn't take long for each lab to extend its contribution into adjacent areas."[13]

Hewlett and Packard had already seen what innovation might result. Just two years prior, the 5060A cesium beam atomic clock had been the result of a "dream team" with different specialties: Alan Bagley was already working with his team on accurately measuring frequency and time for physicists, astronomers, and standards bureaus in countries across the world. Teaming up with Barney Oliver and Bill Hewlett, Bagley recruited quartz crystal expert Don Hammond. And Oliver, soon to become the first leader of HP Labs, had deep knowledge of radio astronomy and space communications.

In a post-Sputnik world, the need for precise synchronization in communications became more pressing than ever. The team's 5060A, the first all solid-state cesium clock, had a practicality and precision that earlier versions of the atomic clock could not match.

" . . . Satellite communication requires synchronization capability that can only be ensured by atomic clocks. The HP 5060A cesium-beam standard instantly became *the* standard for international time, and was even used to corroborate Einstein's mathematics of relative time and the shifts with time travel."[14]

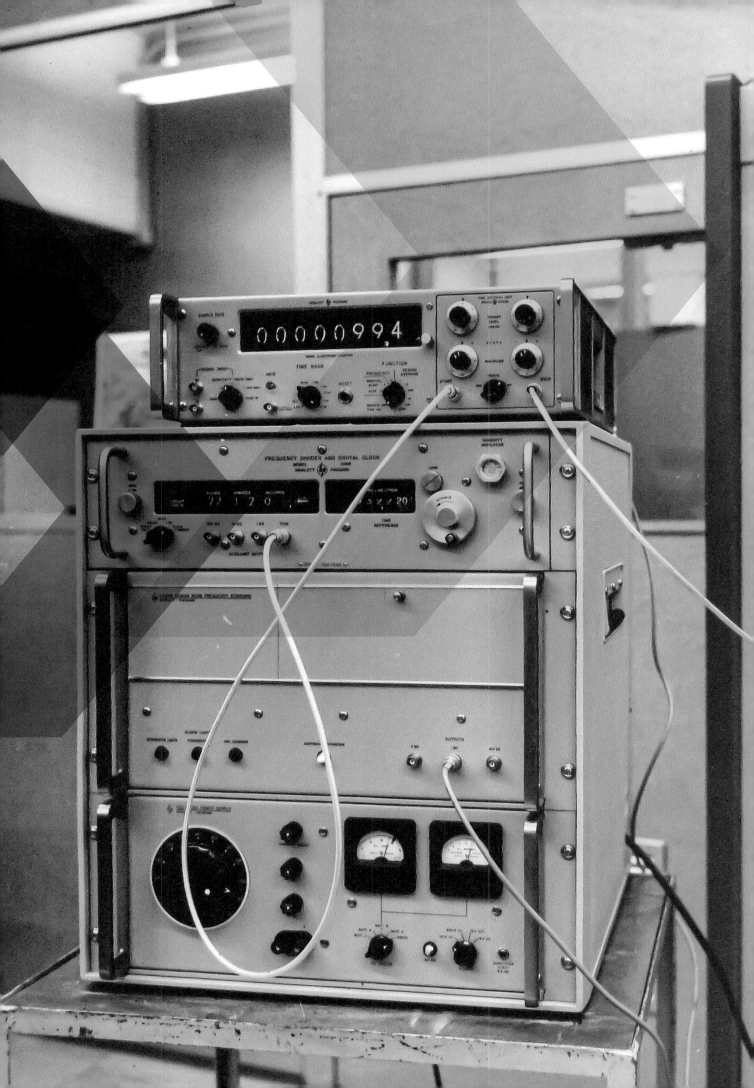

It was the beginning of an entirely new phase in cesium clocks, and arguably the most important in terms of practical application. Reliable, compact (it could fit into an airline seat), and equipped with a backup battery, the 5060A could finally allow synchronization across long distances. In 1964, Bagley and his colleague Leonard Cutler staged a dramatic demonstration: they first synchronized two of the clocks in California, then flew them to the US Naval Observatory in Washington, D.C., to a conference in Switzerland, and then to Colorado to compare with the standard kept there. Not only did the 5060A prove its dependability and portability, it was staggeringly accurate.

Even more high-profile tests of what had become known as the "flying clock" followed:

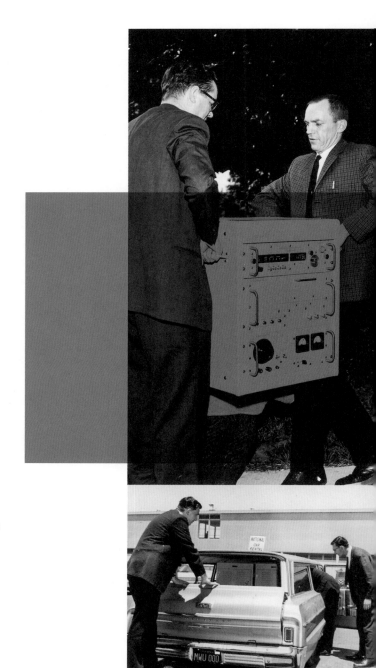

"A second trip, an around-the-world affair with one machine, started February 12, 1965, and took thirty-five days and thirty-five thousand miles, during which standards were calibrated for twenty-one groups in eleven countries. The most ambitious was a dual around-the-world trip, when Dexter Hartke and Ron Hyatt went west to east, while Lee Bodily went east to west. The two teams met in Neuchâtel, establishing remarkable correlation for all of the major world time-keeping organizations, as well as verifying the ability of these new machines to operate in less-than-ideal environments – small enough to travel, operate on a variety of power sources, and take temperature and humidity variation."[15]

The 5060A would be a linchpin in facilitating space travel, and the technology behind it would provide a crucial component of modern cellular networks and global positioning systems. In effect, engineers around the world could now rely upon a level of synchronization that allowed them to think, design, and deliver products that operated on a global stage.

AN AROUND-THE-WORLD AFFAIR WITH ONE MACHINE

TOP LEFT: UNLOADING AT THE US NAVAL OBSERVATORY, 1965

LEFT: THE NEW CLOCK WAS COMPACT ENOUGH TO FIT INTO A STATION WAGON OR STRAP INTO AN AIRPLANE SEAT

ABOVE: CALCULATING TIME ACCURACY BETWEEN THE SWISS OBSERVATORY AND THE US NAVAL OBSERVATORY, 1964

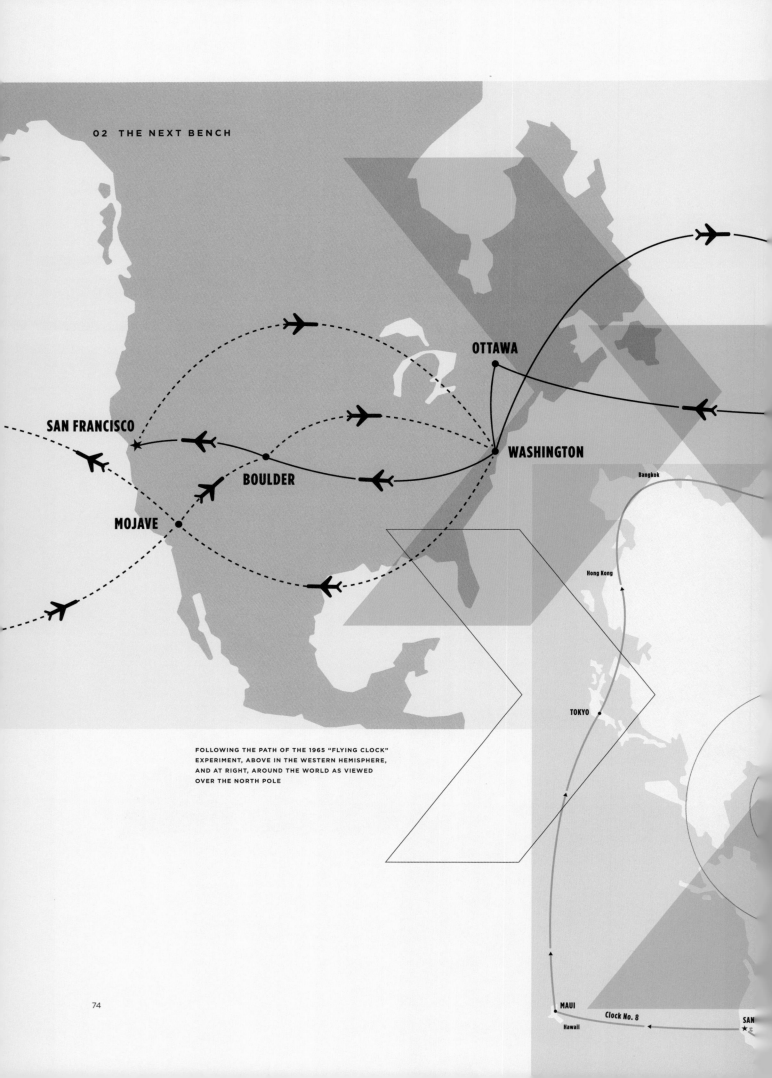

OTTAWA

SAN FRANCISCO

BOULDER

WASHINGTON

Bangkok

MOJAVE

Hong Kong

TOKYO

FOLLOWING THE PATH OF THE 1965 "FLYING CLOCK"
EXPERIMENT, ABOVE IN THE WESTERN HEMISPHERE,
AND AT RIGHT, AROUND THE WORLD AS VIEWED
OVER THE NORTH POLE

MAUI Clock No. 8 SAN

Hawaii

LONDON

GENEVA

Bombay

Karachi

Cairo

Athens

COPENHAGEN

HAMBURG

MILAN

TURIN

STOCKHOLM

NEUCHÂTEL

OSLO

PARIS

BRUSSELS

LONDON

OTTAWA

NEW YORK

Clock No. 9

WASHINGTON

ULDER
Denver

11 COUNTRIES IN 35 DAYS

The Apollo moon shot made precise timekeeping more important than ever – a difference of just one microsecond could throw a satellite more than 300 meters off course. The "Flying Clock" experiment in 1965 set out to measure the accuracy of the 5060A by visiting 21 facilities in 11 countries to synchronize and compare time standards around the world.

The trip had its share of small dramas. The journey covered about 35,000 miles by air and 2300 miles by car. It involved nine airlines and eight different kinds of aircraft, usually traveling commercial at a half-fare "children's rate" right in the main cabin. Although there was nothing fissionable in the clock, just the word "atomic" caused ripples; the trip from London to France was switched to a different flight when the first airline balked at carrying it. Initially curious passengers often moved to seats further away. And the London police, taking no chances with anything containing "atomic" material, provided a motorcycle escort from the airport.

The clock, however, proved just how rugged it was on a five-hour car journey over rough roads to and from a tracking station in Japan, and the battery backup showed its mettle when a well-meaning hotel employee turned off the light switch the clock was using to charge. The experiment itself was a smashing success. Commitment to quality, and persistence in the service of making a technical contribution; fundamentals of the HP Way powered this global odyssey, just as it continues to power HP teams around the world.

A RESILIENT CREATIVE PRINCIPLE

Meritorious Defiance

A credit to an exceptionally strong culture built upon the HP Way, the next bench phenomenon was an extraordinarily resilient creative principle within HP; so much so that engineers would go with their gut – and their listening instincts – even in the face of managerial resistance at the highest levels.

In 1966, a young engineer named Charles House came up with a design for an oscilloscope with a large display while working on a project for the FAA. While the prototype he built didn't fit the project, it was impressive on its own, with a much larger, faster display than had been previously possible.

It would take customer input – and a little subterfuge – for this new display to see the light of day. In the context of an oscilloscope, the joke around the office was that it was built for a near-sighted engineer. But when the division manager was hospitalized with a heart attack, he had his wife call to see if the team could bring the unit to the hospital – it would allow him to watch his own EKG measurement as he lay in bed. It was only the first of many ideas of the way the display could be used.

House, excited by the possibilities, convinced his superiors to let him extend the next bench approach beyond the walls of HP and take the prototype around to potential customers over a personal holiday trip:

"I met with twenty potential customers in two weeks. In terms of generating excitement, it was phenomenal. I talked with people who wanted to display computer signals, folk hoping to create space video images, medical doctors seeking surgery room displays – even astronomers. They all reacted with enthusiasm."[16]

CHARLES HOUSE, HP RESEARCH & DEVELOPMENT, 1962-1991

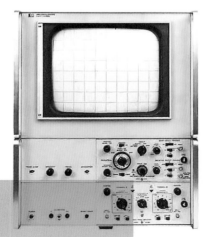

THE NEW CRT DISPLAY OFFERED EASIER READOUT FOR TEST EQUIPMENT SUCH AS THIS MODEL 143A OSCILLOSCOPE

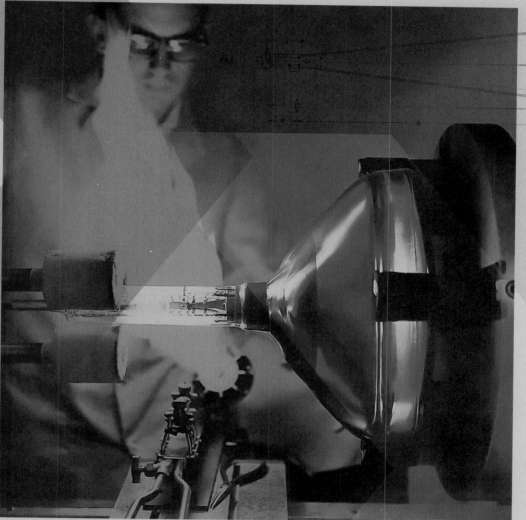

AN HP GLASS TECHNICIAN PREPARES TO MAKE A
PART FOR THE MODEL 1300A

LARGE-SCREEN CATHODE-RAY TUBE DISPLAY

1967

PLANTING THE SEEDS OF A NEW MARKET

HP ENGINEER CHARLES HOUSE

A separate market forecast back home, however, predicted total sales of 32 units. At a division review, Dave Packard reportedly told management that "When I come back next year, I don't want to see that project in the lab." The engineers took it as a challenge, getting the display into production in 10 months instead of the projected 18. At the next division review, Packard was livid, thundering, "I thought I said to kill this project!" By then, however, the display was selling – and selling well, to HP's oscilloscope customers as well as a number of more unexpected places. In the face of Packard's anger, House replied "No, sir, you said you didn't want it in the lab – it isn't, it's in production."

The 1300A X-Y Display would be embraced by industries well outside HP's still-primary scientific market. Hollywood filmmakers used a version of the display for computer graphics; doctors used it to monitor the first artificial heart transplant; and NASA used the display to track Neil Armstrong's famous walk, for which it was dubbed the "moon monitor." It would go on to earn HP more than $35 million.

In 1982, House was presented by Packard with the company's first and only "Medal of Defiance," recognizing his "extraordinary contempt and defiance beyond the normal call of engineering duty" in "plant[ing] the seeds for a new market."

The Next Desk

Used to working elbow-to-elbow in the garage, Bill and Dave continued in close quarters as the company matured. Their connected offices at 1501 Page Mill Road gave them a view of each other's desks, a reflection of their collaboration in running their young company. They advocated an open-door policy, where workers could come in any time to voice concerns.

That policy both demonstrated and developed trust amongst their staff. On being asked whether leaving their offices constantly open might not lead to things disappearing, Hewlett decided to put it to the test, leaving a penny out on his desk to see if anyone grabbed it. No one ever did. This small act of trust evolved into workers and visitors leaving their own money on the desk, which HP now donates to charity as an homage to Bill.

The company was an early adopter of the office cubicle, so that workers could exchange ideas and move around the office – a reinterpretation of the engineer's workbench. The Redwood building, the first building the company built itself, purposely minimized the number of walls to keep the space open. Bill and Dave went even further, pushing for policies such as leaving equipment lockers open, to let employees work on their own experiments after hours:

"It was not unusual to find Bill in the plant on weekends. Perhaps he was working on an antenna for the fly-in airstrip, on the ranch he and Dave owned in South San Jose. On one weekend evening, he was working on a radio antenna, and needed some parts from Lab Stock. It was the late 1960s and division management was on a cost saving initiative, which came and went, in cycles. Some manager or bean-counter decided that open lab stock was a license to steal, so the lab stockroom door had a padlock on it, after working hours and weekends.

Bill called a guard to open the tool room door in the facilities department, to bring him a bolt cutter tool. He cut off the padlock, got his parts, and left a note on the stock room door to the effect, 'Don't ever lock this door again,' signed Bill Hewlett. Guess how many years that that note prevented lab stock doors from being locked? Such action gets around – everywhere!

Bill's attitude was that we hire expensive design engineers to create new products. At the same time, many have hobbies, such as ham radio or audio system design, which teach them new design tricks, useful in their regular HP job. Bill was willing to accommodate the use of HP parts, from the lab stock, to assist the engineers in their off-duty hobbies."[17]

JOHN MINCK

OPEN SEATING AT THE HP CUSTOMER WELCOME CENTER

Extending the Bench

The fruits of the next bench phenomenon within the walls of HP, however, did not always pay immediate dividends. Sometimes it took decades for the world to catch up with an idea too early for its time. In other instances, the chance to learn from mistakes helped the company pay closer attention to the customer on the figurative next bench.

Today we take the sight of an Apple Watch or a Fitbit tracker in stride, if we notice it at all; wearables are a part of everyday life for millions. In that sense, HP was far ahead of its time when it debuted the HP-01 wristwatch calculator in 1977. It was a technical triumph, involving multiple divisions and dozens of employees in its development. But the HP-01 also demonstrated the limits of keeping "next bench" listening inside the company, and signaled the need to expand whose considerations mattered most.

"Time: elusive and immediate . . . limited yet infinite. Because time is important to you, Hewlett-Packard introduces the HP-01, a new dimension in time management and personal computation.

It's a digital electronic wristwatch, a personal calculator, an alarm clock, a stopwatch, a timer, a 200 year calendar . . . and yet it is more than all of these. The HP-01 is a unique, interactive combination of time and computation functions that offers unmatched capability and versatility. You can do anything from viewing the time to dynamically calculating the cost of a long distance phone call or, if a pilot, finding the distance to your next checkpoint."

FROM THE COMPANY'S INTRODUCTION

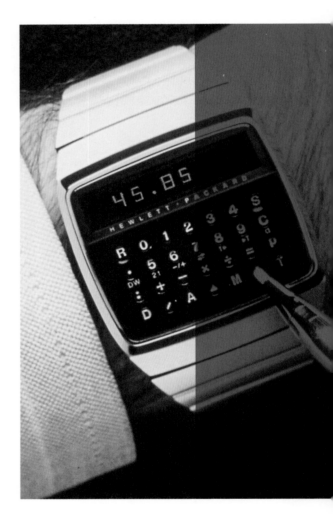

THE HP-01 WAS A TECHNICAL MARVEL

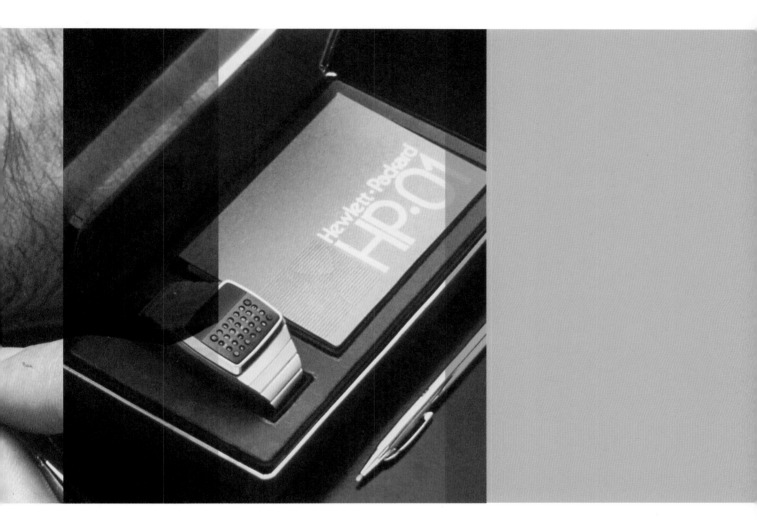

The HP-01 – a designation the company had held in
reserve for years – was a marvel of miniaturization, with
28 tiny keys on its face that required a stylus that cleverly
snapped into the watch's clasp. It was smarter than many
pocket calculators, with more than three dozen functions
related not only to arithmetic, but to timekeeping and
calendar functions.

A CALCULATOR, AN ALARM CLOCK, A WATCH, A STOPWATCH, AND A 200-YEAR CALENDAR FOR YOUR WRIST.

While visionary in its capabilities, it was not a success. The Advanced Products Division, recently moved to Oregon and removed from the heart of the Valley, had certainly pulled off a feat of engineering, but there were too many reasons for consumers not to buy it. It was too bulky to pull a shirt sleeve over it, using the stylus was a bit cumbersome, and the buttons were too tiny for older eyes.

The HP-01 has enjoyed a resurrection of sorts, as one of the most sought-after collectibles in vintage electronics, routinely fetching 5 or 6 times its initial $750 price. But the real success of the HP-01 may be in the lessons learned as the company moved toward the age of personal computing. Evolving its focus from its test measurement roots (and customer base) meant the idea of the bench would have to evolve along with it.

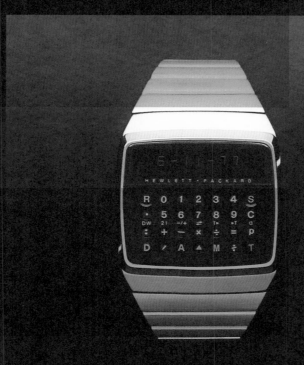

HEWLETT **hp** *PACKARD*

HP-01
WRISTWATCH CALCULATOR

NOW A SOUGHT-AFTER COLLECTIBLE

PERCOLATING POSSIBILITIES

Listening for Customer Need

High-quality printing available to every home still seemed like a pipe dream when the 2680, HP's first laser printer, debuted in 1982 at a cost of $100,000 for the machine and its accompanying software packages (nearly $275,000 in 2021 dollars). But with teams in both laser and inkjet technology racing to produce better, faster, quieter and cheaper printing options – sometimes in direct competition with one another – it was only a matter of time.

"Inkjet technology was born around the coffee pot at HP Labs, our central research facility, as a couple of engineers discussed the principle of vaporization that operates coffee percolators. That led to the development of small resistors, heated by an electric pulse, [creating] a vapor that ejects ink through a nozzle."[18]

LEW PLATT, HP ENGINEERING, CEO 1992–1999

It would take more than five years to debut the ThinkJet, the first product based on that technology – and the world's first mass-marketed, personal inkjet printer.

The company was dialing in to what customers wanted on a much broader scale. At its debut in 1988, the monochrome DeskJet was still unaffordable for most at nearly $1000, but it was user-friendly enough to sound the death knell for the noisy and cumbersome dot-matrix printer. Within two years, the DeskJet would be priced at $365 to move printing out of the office and into the home.

But HP wasn't done listening. Most color printers at the time did not also have black-and-white capability; only customers with specific needs could justify their high price. A worldwide internal study, however, indicated massive potential; if HP could create a printer that could print both monochrome and color, at the quality and price point of the black and white LaserJet, it would completely reshape the printer market.

Code-named "Bedrock" in development, the DeskJet 500C would go on to do just that. Within three years of its debut in 1991, HP was selling four million color printers a year and cementing its dominance in the consumer print market.

THE USER-FRIENDLY DESKJET REPLACED NOISY, CUMBERSOME DOT-MATRIX MACHINES

FROM THE 2680 ENTERPRISE LASER SYSTEM TO THE TINY
THINKJET, HP IGNITED A REVOLUTION IN PRINTING BY
GAUGING CUSTOMERS' NEEDS

THE HP BIOPRINTER IS OPENING UP NEW APPLICATIONS
IN DIAGNOSTIC TESTING AND PHARMACEUTICALS

THE NEXT BENCH IS ESSENTIALLY THE WORLD

Today's Bench

"The design was done through what we called the 'next bench syndrome.' You designed something and you gave it to the engineer at the next bench. Well, in many ways, getting your clients and customers applying the same theory now in a social networking arena, the next bench is essentially the world. You can now get consumers involved, not just the engineer beside you."[19]

RON McKENZIE, HP MARKETING MANAGER 1995–1996

While HP's engineers may no longer be routinely trading ideas between workbenches, the company continues to listen for what is most needed, or how to make lives easier or better. Notable examples of the last decade include:

+ *A line of displays, PCs, and peripherals developed in conjunction with healthcare providers and engineered to be sanitized regularly*

+ *The industry's first sanitizable printers, along with touch-enabled control panels that can be used through nitrile and other medical gloves*

+ *The HP Sprocket portable photo printer, reconnecting social-media culture with the tactility of an actual printed photo*

+ *The application of inkjet technology to the world of microfluidics, from non-invasive biopsies to accelerated testing of new antibiotics*

HP SPROCKET PORTABLE PHOTO PRINTER

A MUTUAL RESPECT FOR EACH PERSON'S IDEAS

While each of these products addresses a distinct need – sparked by timeless HP principles of listening to customers and making a contribution – product development at today's HP looks further to the future than ever before. In some instances, new product possibilities are realized relatively rapidly through the logical extension of current product lines. In other instances, however, the courage to leap ahead – beyond perceived technical constraints and short-term market considerations – reflects an evolution of the HP Way. Continuously accelerating competition for the future requires new business calculations. Today, those calculations inform a design methodology that is, in fact, called LEAP: Learn, Explore, Assess, Progress.

"When I meet people that have come over from competitors, they say, 'we were trying to do that product for years and never got it off the ground.' It's because they kept trying to push it through the system – through the lens of what's possible today. They were met by the cost, met by the technology, met by a review, maybe with product management, or an executive or a retailer who wasn't ready for it. If you leap ahead and solve customer pain points, it shifts everyone's mindset."

STACY WOLFF, HP GLOBAL HEAD OF DESIGN & SUSTAINABILITY

Leaping ahead often means overcoming profound technical challenges; challenges that might occasionally be hashed out around a pot of coffee or a visit to the "next desk." But for a company of HP's size and ambition, shared expertise and collaboration goes well beyond the constraints of a single pot of coffee, or a single office. Inside the HP of today, the next bench is fueled by a technical community more than 18,000 people strong, distributed all over the world. Each may be dedicated to a particular product or product line, but – in an era of digital collaboration and hybrid work – they come together as communities of practice, together pushing the boundaries of what is possible. It doesn't matter what country they are in, what business unit they work for, or where they exist in the corporate hierarchy.

"Each community is driven by co-leads who passionately stepped forward. Some leaders are early career contributors and some are experienced contributors. There is no hierarchy. These virtual communities of practice are self-organized by capabilities and skills such as data sciences, security, materials, sustainability fundamentals, etc. The mission of each community is to learn, teach, guide, and come together to solve multi-disciplinary problems. As most problems are systemic, spanning multiple capabilities, we bring together multiple communities to solve problems on a regular basis."

CHANDRAKANT D. PATEL P.E., HP CHIEF ENGINEER AND SENIOR FELLOW

Just as the original next bench phenomenon was an organic realization of product evolution opportunities vetted by respected colleagues an arm's length away, these communities of practice are self-forming, self-governing entities motivated by a mutual respect for each person's ideas; ideas that are but a keystroke or video conference away.

SECURITY

DATA SCIENCE & KNOWLEDGE
DISCOVERY (AI)

HEAT, MASS
MOMENTUM &
CHARGE TRANSFER

MATERIALS

SUSTAINABILITY FUNDAMENTALS
& TECHNOLOGIES

IMAGING & COLOR

HP'S SCHOOL OF TALENT INITIATIVE CLUSTERS TECHNICAL SKILLS
IN LIGHT OF CURRENT AND FUTURE BUSINESS NEEDS

**HEWLETT AND PACKARD MAINTAINED A DIRECT
LINE OF SIGHT BETWEEN THEIR OFFICES**

AN OPEN-DOOR POLICY BOTH
DEMONSTRATED AND DEVELOPED TRUST
AMONGST THE STAFF.

**TOP: VISITORS LEAVE MONEY ON HEWLETT'S OLD
DESK AS HOMAGE**

**BOTTOM: THE HP-25 WAS THE LEAST EXPENSIVE AND
SMALLEST OF HP'S PROGRAMMABLE CALCULATORS**

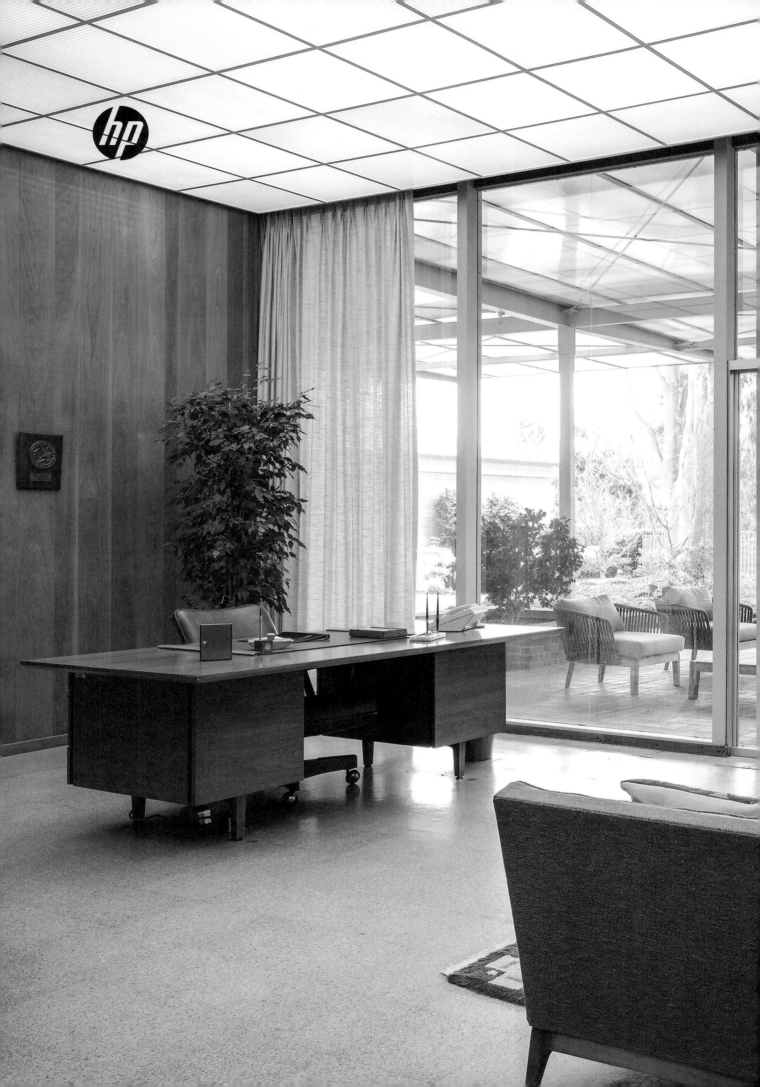

03

CREATIVE PEOPLE HAVE AN ABIDING CURIOSITY AND AN INSATIABLE DESIRE TO LEARN HOW AND WHY THINGS WORK. THEY TAKE NOTHING FOR GRANTED.

Bill Hewlett

HUMAN POTENTIAL

03 Human Potential

Playing an Indispensable Role

The arc of human achievement over the past century: a story of breakthroughs, the never-before-possible, and the exponential acceleration of innovation. The power of the atom, space flight, heart transplants, the personal computer – in many instances, HP played an indispensable role; sometimes behind the scenes, sometimes front and center. It was no accident. From within its walls emanated a belief in human potential that began with a respect for the individual and extended to the teams and operating units that made purposeful decisions about what to design and manufacture – for the business and for the world.

"From the day I joined, it was pounded into me about making a contribution. And not a contribution for contribution's sake, but a contribution that really meant something to the world. We really believed we had the opportunity to change the world."[20]

NED BARNHOLT, HP 1966-1999, AGILENT CEO 1999-2005

ADVANCEMENT AFTER ADVANCEMENT

Journey to the Stars

By the time NASA was born in 1958, HP instruments were already in use for space exploration. The 560A Digital Recorder had been used to measure the height of Sputnik I the year before, and HP instrumentation was used in the design, testing and monitoring of American satellite Explorer I and the Pioneer Station DSS-11 deep space antenna.

On the day of President John F. Kennedy's famous 1961 speech challenging the country to put a man on the moon by decade's end, only one American had even flown in space – less than a month earlier. Landing humans on the moon would require the most intensive burst of technological creativity, underpinned by the largest commitment of resources, that any nation had ever made during peacetime.

As the Space Race heated up, the Apollo Program produced advancement after advancement in telecommunications, timekeeping and scientific discovery, laying much of the groundwork for the modern Information Age. It was a time of national unity, with scientists, engineers and companies all over the country working together towards a common goal. HP products could be found in every corner of the Apollo Program. Innovation, making a contribution – the company's bedrock values were a natural fit for an ambitious and demanding national project.

To learn how space flight affected the human body, astronauts were closely monitored by HP equipment. A Sanborn eight-channel recording system tracked John Glenn's breathing and heart rate in real time aboard Friendship 7 as he became the first American to orbit Earth. The Sanborn 350 recorded Gordon Cooper's temperature, respiration, heart rate, and other vital signs before and during his flight on Faith 7, the last of the Mercury manned space flights, so that changes occurring in orbit could be recorded and studied.

MODEL 560A DIGITAL RECORDER, OUT OF ITS CABINET

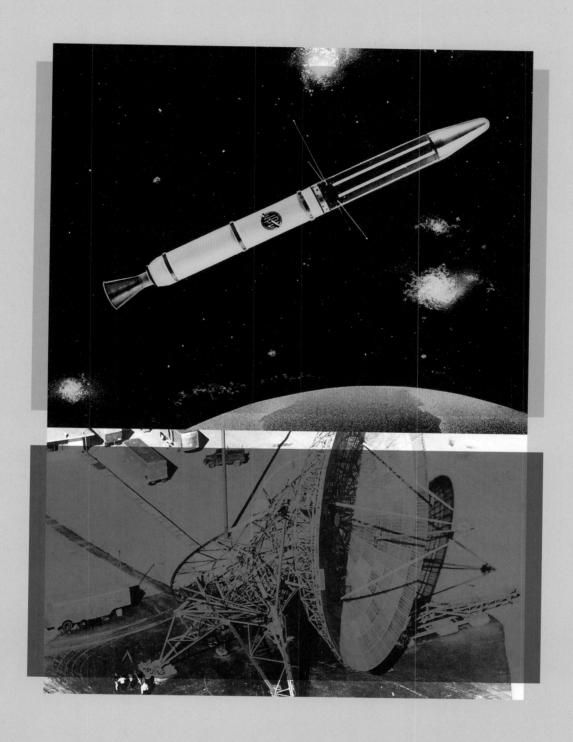

EXPLORER I + PIONEER STATION DSS-11

1958

MONITORING
THE EFFECTS
OF SPACE
FLIGHT

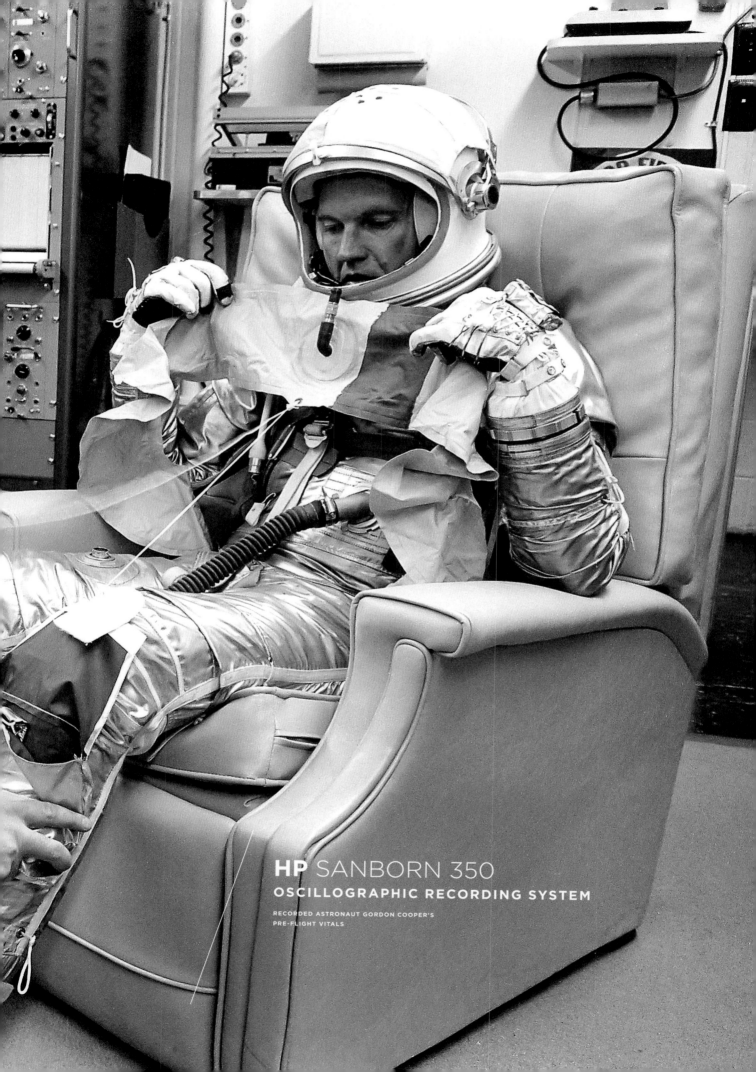

HP SANBORN 350
OSCILLOGRAPHIC RECORDING SYSTEM

RECORDED ASTRONAUT GORDON COOPER'S
PRE-FLIGHT VITALS

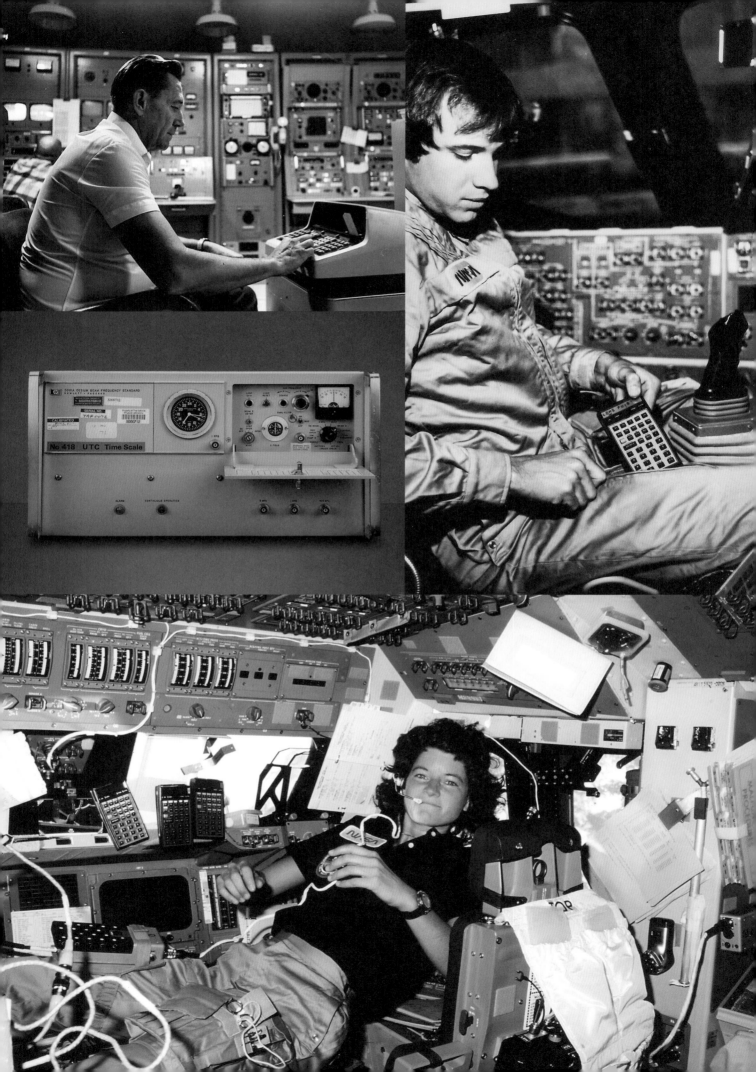

By the time Apollo 11 launched, HP products were in place throughout the space program. The 5061A cesium beam frequency standards that synchronized the worldwide Apollo tracking network and ensured navigational accuracy were perhaps the most high-profile legacy. In fact, almost every company division contributed to the space-flight initiative. HP frequency synthesizers and data acquisition systems, for example, were used to test and calibrate the lunar module; NASA's control centers at Cape Kennedy and in Houston employed precision picture monitors and signal generators to observe and communicate with the astronauts; and Jet Propulsion Lab scientists used a new HP signal averager to analyze moon rocks.

Even systems from other companies made widespread use of HP products, such as PIN switches in the guidance antenna system, or step recovery diodes in the astronauts' communications system. The tracking stations themselves were "veritable storehouses"[21] of HP equipment, from frequency synthesizers to desktop calculators, amplifiers to recorders, signal generators to voltmeters. HP's commitment to quality meant that even off-the-shelf products were subjected to rigorous environmental testing to ensure the mission's success.

"It is interesting to note that these instruments meet our standard HP commercial specifications and yet were good enough to be selected by NASA for this critical role. This is a very great tribute to the commercial quality of our products. It is exactly this kind of quality on which the company has built its reputation."[22]

BILL HEWLETT

REACHING THE STARS

Ensuring Success

As space flight advanced, so too did the HP components and instruments upon which it relied. The Viking craft sent to Mars in 1975 had HP IMPATT diodes at the heart of the radar system that determined its distance from the planet's surface and speed of descent. As America moved into the Space Shuttle age, NASA used HP-41C calculators as supplements and backups to the Shuttle's own computing power:

"The Shuttle's primary functions were still controlled by an on-board, custom-designed system . . . But the HP-41C took a lot of the computing load off that machine for mundane but necessary calculations, such as calculating when a given ground station was available to send data to or receive a communication from. The HP-41C also contained a clock, which allowed astronauts to set alarms and schedule experiments. (The clock was not available to consumers at the time of the first Shuttle launches, but NASA obtained pre-production modules that plugged into the calculators. Hewlett-Packard later offered these as an option.)"[23]

KEITH JARETT, PERSONAL COMPUTING MAGAZINE

THE IMPATT DIODE, ONLY 1/8 INCH LONG BUT A HUGE ADVANCE IN MICROWAVE POWER

1981

CANADARM I

INTERNATIONAL SPACE STATION

2019

After the Challenger explosion of 1986, HP's Integrated Systems Division built NASA a pair of test stations to use in preflight checks of the Shuttle's new main engine controller. In place by 1992, the systems pulled together a number of HP test products, including the HP 9000 Series 360 computer, the HP 3245A waveform generator, and an HP 54501A digital scope. HP equipment was also at work testing the massive Canadarm mechanical arm used by the Shuttle program to deploy or service satellites.

HP continues to support the drive to explore space. In 2016, HP ZBooks began replacing 100+ existing workstations and laptops on the International Space Station. The ZBooks were selected for their reliability and ruggedness; HP custom-designed a version for NASA that withstands drops, shock, extreme temperatures, and years of radiation exposure. HP also developed and deployed a custom HP Envy printer for zero gravity use: glass removed for better safety and reduced weight; a special output tray to keep printed items from floating off, and all plastic parts replaced with fire-retardant alternatives.

Back on Earth, the company began in 2011 to modernize NASA's entire desktop fleet and provide support for its 60,000 employees. Z8 desktop workstations allowed NASA researchers at the Solar Dynamics Observatory to use big-data analytics on petabytes of information – bringing otherwise highly-restricted supercomputing resources right to data scientists' desks.

"The data science workstations completely changed the field of possibility for us. These computations that previously weren't imaginable, we can now do 10-150x faster than we thought possible."[24]

MICHAEL KIRK, NASA RESEARCH ASTROPHYSICIST

SUPPORTING CONTINUED EXPLORATION

HP Z8 G4 WORKSTATION USED BY NASA RESEARCHERS

SETTING NEW STANDARDS FOR PATIENT CARE

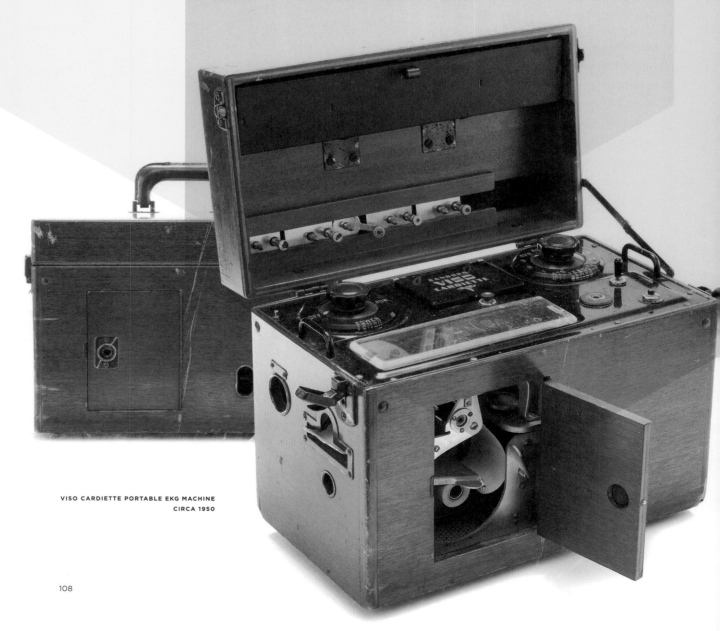

VISO CARDIETTE PORTABLE EKG MACHINE
CIRCA 1950

Leaps in Medicine

Bill Hewlett once confided to a Stanford biology professor that, had he followed a different path, he might have been a physician rather than an engineer.[25] His father, Albion Hewlett, was a brilliant doctor, a pioneer in cardiovascular medicine and the chair of medicine at Stanford Medical School. Though Bill lost his father when he was only 12 years old, that influence echoed years later in Bill's deep interest in medical electronics and HP's entry into the medical field with the 1961 acquisition of the Sanborn Company.

Sanborn was HP's largest acquisition of the 1960s and became its first East Coast division. It had a solid reputation in medical circles with products such as the Viso Cardiette, a portable electrocardiograph. And while the Medical Division got off to somewhat of a slow start within HP, by the mid-1960s HP's research and development labs were working aggressively on significant improvements in monitoring and diagnostics adopted by hospitals around the world, technologies that altered the way clinical medicine is practiced today.

This was no easy task. Many doctors didn't trust electronics, and with good reason; most devices had few protections in place for the patients themselves. HP's drive for innovation, together with its bedrock desire to make things not just better, but better for actual people, led to a series of new devices and helped establish important new standards for patient care. The Viso Cardiette evolved into the Model 100 electrocardiograph, with better accuracy and reliability, and which could even relay ECG information over telephone lines for long-distance monitoring.

BILL'S FATHER, DR. ALBION HEWLETT

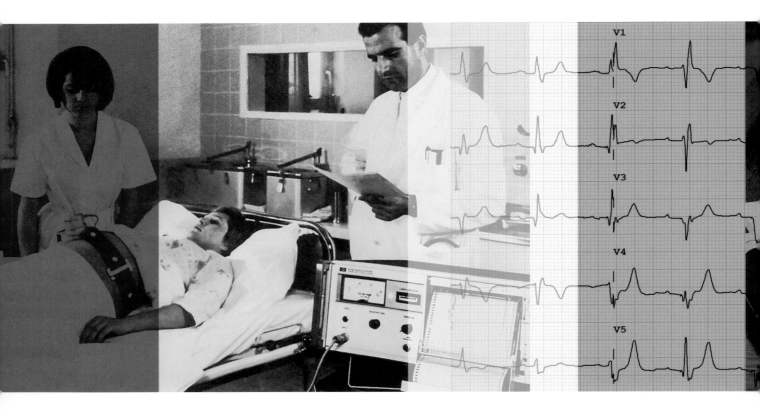

ADVANCING HEART MONITORING

A key breakthrough was the HP 8020A, the world's first non-invasive electronic fetal heart monitor. A collaboration between HP's German division and a German doctor, the 1968 introduction of the 8020A was a monumental advancement over contemporary methods that relied on the human ear and could check a fetus's heartbeat only periodically.

For the first time, doctors could continuously monitor the intervals between a fetus's heartbeats, filtering out other noises and keying the heartbeat to labor contractions on one real-time chart. This let medical personnel know exactly when the heart rate indicated distress, giving them a much-improved chance to save both mother and baby.

FROM THE 8020A ONWARD, HP CONTINUED FOR DECADES TO
ADVANCE VITAL HEART-MONITORING TECHNOLOGY

HP took that breakthrough and expanded it several years later into the 8021A, combining ultrasound, direct ECG, and other indicators in one device. Innovations followed introducing fetal telemetry, ultrasound telemetry, and advancements in signal processing, all while getting smaller and more flexible. By the late '90s, HP introduced the Viridia Series 50T telemetry system, allowing women in labor complete freedom to move around – even shower – while fetal signals were being relayed back to monitors.

But it was not just mothers and babies benefitting from HP's rapid advancements in medical monitoring. The 1504A electrocardiograph gave HP broad coverage of the ECG market by virtue of its compactness, serviceability, and low price – the Medical Electronics Division's equivalent of the HP-35 pocket calculator. Combining the ECG with an oscilloscope, a scope camera, and an electronic counter allowed for accurate pacemaker testing and a dramatic reduction in failures. Advances in plotting and recording technology resulted in PageWriter systems with flexibility in recording formats and data types.

PERFECTION
IS ESSENTIAL

Accurate measurement and monitoring capabilities have opened up new avenues for life-saving surgeries. In 1963, Sanborn designed and built four surgical monitoring systems for the National Institutes of Health: "the most comprehensive electronic monitoring systems ever built for acquiring, recording, and visually presenting data on patients while they are undergoing surgery."[26] Besides condensing the monitoring system into less space, the technical advancements in the way these systems recorded and displayed information to surgeons in real time held broad potential for research and diagnosis, as well as surgical technique.

"In a very real sense, then, when we supply our equipment for vital jobs such as these, a great deal is at stake and quality becomes an all-important factor . . . One defective part, one loose wire, or one poorly soldered joint could seriously affect the outcome of the operation. The kind of quality and reliability required in a system such as this must be built in by each workman at each stage of manufacture. Quality and reliability cannot be inspected later."[27]

DAVID PACKARD

With these advancements, along with tools like the 78660A heart monitor and portable defibrillator, even general community hospitals were able to establish cardiac care units and perform open-heart surgery routinely – surgeries that were previously rare, experimental, and limited to the most elite institutions. By the mid-1970s, mortality rates for hospitalized heart attack patients had dropped to 19%, cut in half from 37% before 1960.

HP continues to innovate for healthcare providers. As capturing data becomes ever more critical for health outcomes, HP systems work to keep health data secure, while still allowing medical professionals to access it and collaborate with ease. HP Healthcare Edition displays and laptops are designed for repeated sanitizing and enhanced with simple but secure authentication features. Printers with sterilizable covers – an industry first – are designed to eliminate electromagnetic interference with patient systems and medical equipment. New ways of sharing and processing data are helping with healthcare provider burnout while facilitating better and more complete care. And on the cutting edge, HP's Specialty Printing Systems team is working to apply microfluidics technology to a range of healthcare needs, from non-invasive biopsies of cancer cells to treatment research, "printing" pharmaceutical samples, and antibody testing.

ONE OF FOUR CUTTING-EDGE SURGICAL MONITORING SYSTEMS
BUILT FOR THE NATIONAL INSTITUTES OF HEALTH IN 1963

HP CONTINUES TO DEVELOP SYSTEMS TO SUPPORT BETTER,
EASIER, AND MORE COMPLETE PATIENT CARE

A SAFER AND CLEANER WORLD

Liquid and Solid Substance Measurement

Adjacent but separately from medical instruments, HP expanded into analytic chemistry with the 1965 acquisition of F&M Scientific, one of the world's leading manufacturers of gas chromatography. The technology was still relatively new, but HP quickly added capacities for liquid and solid substance measurement and combined them all into a new Scientific Instruments Division. Continued advancements in the field built HP a solid reputation among chemists around the world.

As environmental concerns accelerated, HP chromatographs were put to use across the country. Government labs installed them to assist with air pollution control, water quality research and analysis, and pesticide control research; university labs conducted basic pollution studies of all types. HP even contracted with the federal government to develop five portable laboratories for food testing:

"Each will be designed to test a different type of food product – grains, forage, dairy products, thick-skinned fruits (oranges), and thin-skinned fruits (tomatoes) – for presence of contaminating pesticide chemicals. Agricultural inspectors will then be able to walk right out into the middle of an alfalfa field, take a sample, run it through the portable, self-powered F&M gas chromatograph, and perform all other necessary tests on the spot."[28]

MEASURE MAGAZINE, FEBRUARY 1967

THE MODEL 5950A ESCA WAS A REVOLUTIONARY BREAKTHROUGH FOR ANALYTICAL CHEMISTRY LABS

HP CHROMATOGRAPHS AND SPECTROMETERS FACILITATED
CLEANER AND SAFER WATER, FOOD AND AIR

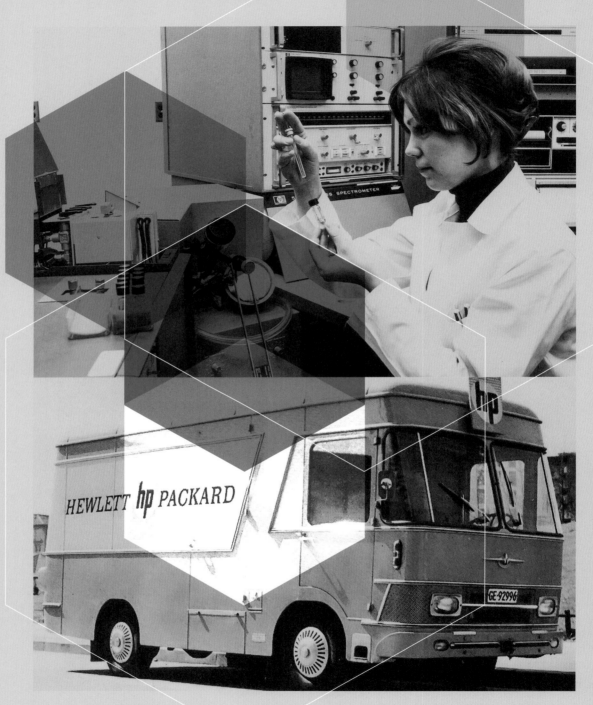

ON THE ROAD IN THE 1960S AND 1970S FOR ATHLETE
DRUG TESTING IN CANADA (ABOVE) AND ITALY (BELOW)

SCREENING FOR FAIR PLAY

In 1971, HP produced the Model 5950A ESCA, the electron spectrometer for chemical analysis – a revolutionary breakthrough for analytical chemistry labs. The potential for the ESCA was enormous for public health. It put precise chemical analysis into the hands of rural towns and public health officials, unlocking sophisticated testing for biomedical diagnoses and pollution enforcement.

HP chromatography has also helped keep the world clean on the athletic field. Olympics officials started to adopt full-scale athlete testing after a German biochemist demonstrated that an HP gas chromatograph could be used to detect anabolic steroids and other substances in the urine samples of athletes. The HP devices took the testing process down from 16 steps to only three, finally making a testing protocol practical. And as doping strategies evolved, so did HP's capabilities. The tests that disqualified sprinter Ben Johnson in 1988 were run on a new HP liquid chromatograph; his coach had believed the illegal substance undetectable.

Food safety, forensics, pharmaceuticals, bioscience – all have been transformed, even made possible, by chromatography and spectrometry. We are healthier, safer, and more secure as a result.

HP 5890 GAS CHROMATOGRAPH DEPLOYED FOR THE 1988 SUMMER OLYMPICS IN SEOUL

UNTIL NOW, ARTISTS HAVE HAD TO WORK AT THE SPEED OF TECHNOLOGY. SOON THEY WILL BE ABLE TO WORK AT THE SPEED OF THE IMAGINATION.[29]

DREAMWORKS CO-FOUNDER JEFFREY KATZENBERG

Creative Expression

Film, fashion, art – creativity is a uniquely human trait, and creators show us new ways of seeing the world around us. As avenues of art and creativity evolve, it is up to technology companies like HP to invent tools that enable artists to bring the ideas in their imagination to the real world.

Coachella, long considered a trendsetter in music, art, and fashion, has in recent years been a natural venue for HP to display how technology can drive art creation and immersion. In 2018, HP Workstations powered 420 drones in an elaborate display over electronic act Odesza's Sunday set, the first concert to feature a live drone show rather than one previously recorded. The dazzling spectacle of light, color, and technical mastery gave a 21st-century twist to the modern fireworks show and presented the sky as a new canvas for artistic expression.

The medium of film is a key part of HP's founding story; Disney's breakthrough *Fantasia* was a key opportunity that fueled the crucial early growth of the company. Decades later, HP was revolutionizing display technology and entering the computer business just as filmmakers were looking for more sophisticated graphics and effects, and the company's products have been behind groundbreaking movie after groundbreaking movie ever since.

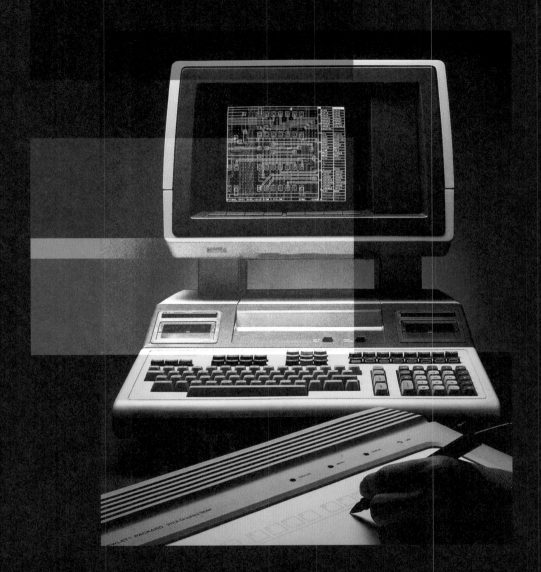

HP 9845C
DESKTOP COMPUTER
**THE FIRST HP COMPUTER TO SUPPORT COLOR, AND
A HUGE ADVANCE IN COMPUTER GRAPHICS**

STAR WARS
TRON
WARGAMES
SHREK
WARNER BRO

Star Wars trilogy: The HP 9826 helped program special-effects shots; HP LED displays were used on the sound cameras developed at George Lucas' studio – a camera that won an Academy Award for its inventors. In 2005, Lucasfilm purchased 1000 HP workstations to power production of its visual effects and video games.

Tron (1982): The HP 9826A was combined with the camera and a controller to dramatically speed up the painstaking animation process. What had previously taken several weeks could be accomplished in just a few days.

WarGames (1983): All of the color computer graphics showing maps and ICBM trails were created using the HP 9845C computer, along with an HP 9874A digitizer. Other HP products helped render the images at the high resolution needed to display them at a size of up to 18 feet wide.

RILOGY

S. STUDIOS

Shrek (2001): As displays transitioned from CRT to flat panels, causing color inconsistencies from scene to scene, HP's invention of a new display (which evolved into the DreamColor) allowed color fidelity even greater than CRTs – and Shrek to maintain his signature green skin color. This kicked off a long partnership with DreamWorks, where animators have used HP Z Workstations and DreamColor displays to power films like *How to Train Your Dragon*, *Kung Fu Panda*, and *Madagascar*.

Warner Bros. Studios (mid-2000s): HP researchers collaborated with Warner Bros. Studios on techniques for digitally restoring some of cinema's greatest classics, like *Singin' in the Rain* and *King Kong*.

HIGH PERFORMANCE ENGINEERING SOLUTIONS

But art across many disciplines, not just moviemaking, is made possible by HP products. The tools of architecture have gone far beyond 2D rendering into virtual reality, 3D site scanning, and generative design powered by artificial intelligence. From the tiny, CAD-certified Z2 Mini through the mighty Z8 tower and ZBook 17 Fury, HP's most high-performance solutions are constantly reevaluated against architecture's demanding processing needs. And when 2D is still the way to go, DesignJet printers are the world's easiest-to-use and most intuitive large-format plotters.

HP has collaborated with *Project Runway* and Vivienne Tam in the fashion sphere both to spark inspiration, and to help designers harness it. Malaysian fashion house Rizman Ruzaini even released a men's collection inspired by the luxurious details of the HP Spectre Folio itself.

ZBOOK FURY MOBILE WORKSTATION

HP Z2 MINI WORKSTATION
DESKTOP COMPUTER & DISPLAY

HIGH PERFORMANCE FOR ENGINEERS AND ARCHITECTS
IN A TINY PACKAGE

VIVIENNE TAM X HP MINI 210

18K GOLD SPECTRE LAPTOPS DESIGNED BY JESS HANNAH
(TOP) AND TORD BOONTJE (BOTTOM) INCORPORATED
DIAMONDS OR SWAROVSKI CRYSTALS

HP's contributions to artistic expression have been recognized with some high-profile awards, including an Engineering Emmy (2020) for ZCentral Remote Boost, providing creative professionals access to high-performance remote computing, and a 2014 Scientific and Technical Award for the development of the HP DreamColor LP2480zx Professional Display from the Academy of Motion Picture Arts and Sciences.

But the greatest honor of all is the trust that creatives put into HP equipment to help them bring their dreams to reality. Even the masters are in good hands; the restorers of Leonardo da Vinci's *The Last Supper* in 1983 used an HP 75 computer connected to an HP 3421A data acquisition and control system to monitor the stress factors on the unstable wall of Milan's Santa Maria delle Grazie that bears the famous fresco.

RESCUING THE PAST

**THE 1983 RESTORATION OF DA VINCI'S *THE LAST SUPPER*
RELIED ON HP PRODUCTS TO MONITOR THE WALL'S
UNSTABLE SURFACE**

FUELING THE EVOLUTION OF COMMERCE

Bringing Ideas to Life

The wide range of print applications in HP's portfolio is a natural complement to the company's historic drive to democratize home printing *(see Chapter 4)*. While customers for the machines themselves are business and industry, on-demand printing opens up the means to bring ideas to life in ways – and at a quality – never thought possible.

HP Latex and HP STITCH printers are reinventing textile printing and bringing vivid colors and sharp definition to fashion and interior design. One-of-a-kind and personalized packaging brought to life by Indigo printers gives companies like Coke and Sapporo new ways to connect with their customers. Specialty Printing Systems utilize HP's expertise to create ever-new ways to print: conductive inks for circuitry and sensors, adhesives and thermal inkjet for manufacturing, even a print engine that allows for printing nail art.

COMPANIES ALL OVER THE WORLD EXPLORE
CUSTOMIZATION WITH HP'S CUTTING-EDGE
PRINT CAPABILITIES

HP JET FUSION
3D PRINTER

THE COMPACT 500/300 SERIES IS DESIGNED FOR
IN-HOUSE AUTOMATED PRODUCTION

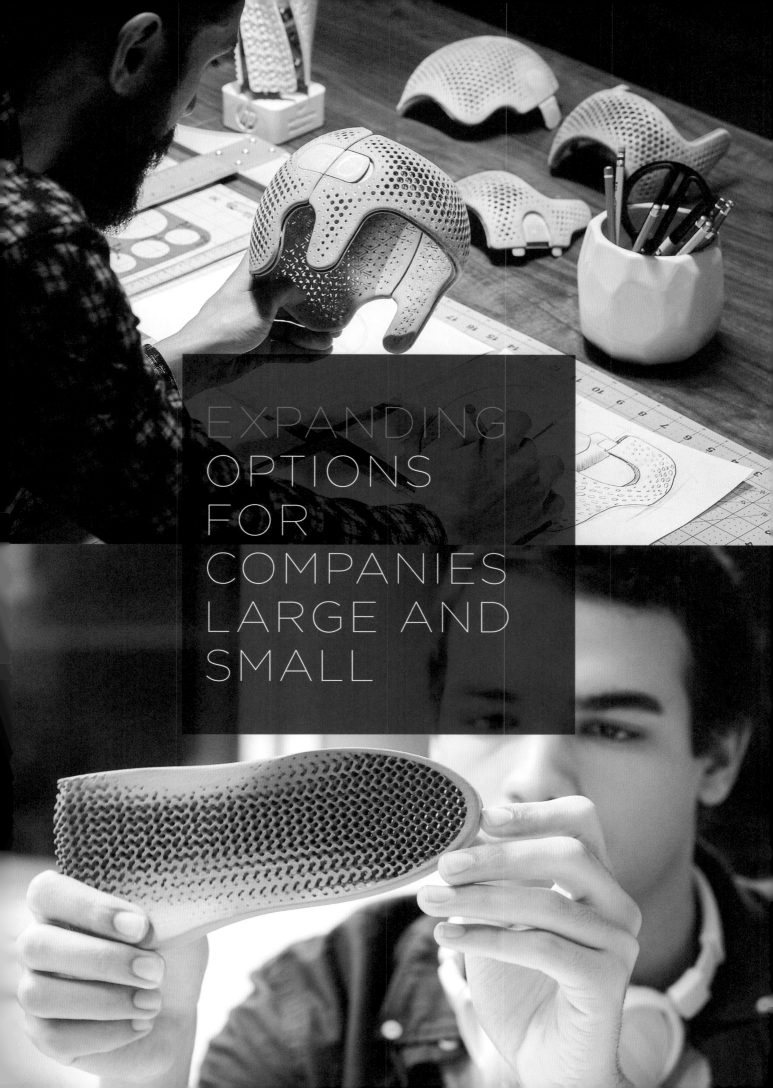

EXPANDING
OPTIONS
FOR
COMPANIES
LARGE AND
SMALL

INNOVATION IN THREE DIMENSIONS

HP MULTI JET FUSION PA 12 BRACELETS

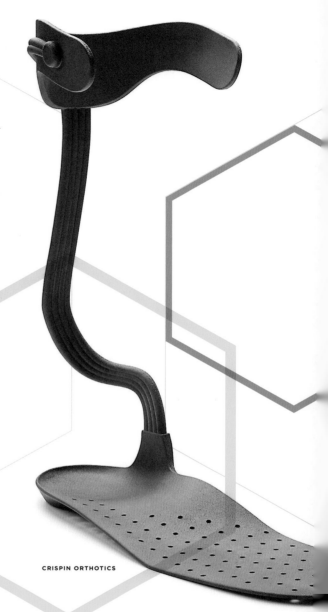

CRISPIN ORTHOTICS

And printing innovation doesn't stop with two dimensions. While a relatively recent entrant into 3D printing, HP has wasted no time in pushing the technology forward. In introducing the Jet Fusion 3200 and 4200 models, the company sounded a familiar "more affordable, more evolved" refrain, promising up to ten times the speed at half the price of existing machines, all with even greater accuracy.

While 3D printing was already commonly used for prototyping, Multi Jet Fusion technology put small-scale manufacturing and customization within reach for far more people, echoing HP's history of delivering personal computers and inkjet printers into as many hands as possible.

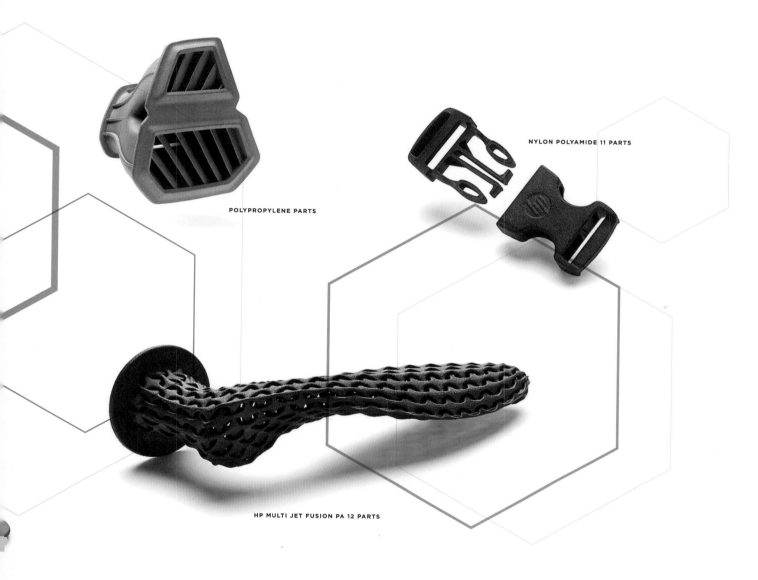

POLYPROPYLENE PARTS

NYLON POLYAMIDE 11 PARTS

HP MULTI JET FUSION PA 12 PARTS

Once again, rather than rushing into a market, HP waited until their 3D printers had real contributions to make. One revolutionary advancement was the ability to print electronics directly into parts using conductive materials at the width of a human hair. Upgraded power within the printer itself, along with a radical increase in the reusability of the material, makes 3D printing faster and more efficient, increasing production volume and decreasing waste.

The HP Metal Jet reaches build speeds up to 50 times faster than competing technologies, while being both less expensive and more reliable. While there are a number of companies working on 3D printing technology, HP's rapid iteration has launched it to the front of the pack. From custom shoes for pro athletes to perfectly fit prosthetics, HP's 3D technology continues to support and advance our human capabilities.

1501 PAGE MILL ROAD NOW HOUSES HP LABS, ONE OF THE PREEMINENT
INDUSTRIAL RESEARCH LABORATORIES IN THE WORLD

MONUMENTAL CHALLENGES BRING ENDLESS POSSIBILITIES

What Can Humans Achieve?

As we look to the next century and beyond – the monumental challenges, the still unfolding possibilities – what can humans achieve? It is a question both urgent and inspiring. It is a question that HP has asked from the beginning; one that it seeded in the birth of Silicon Valley, one that it aligned to the ambitions of a nation, one that it continues to share with the world and everyone in it – one product at a time.

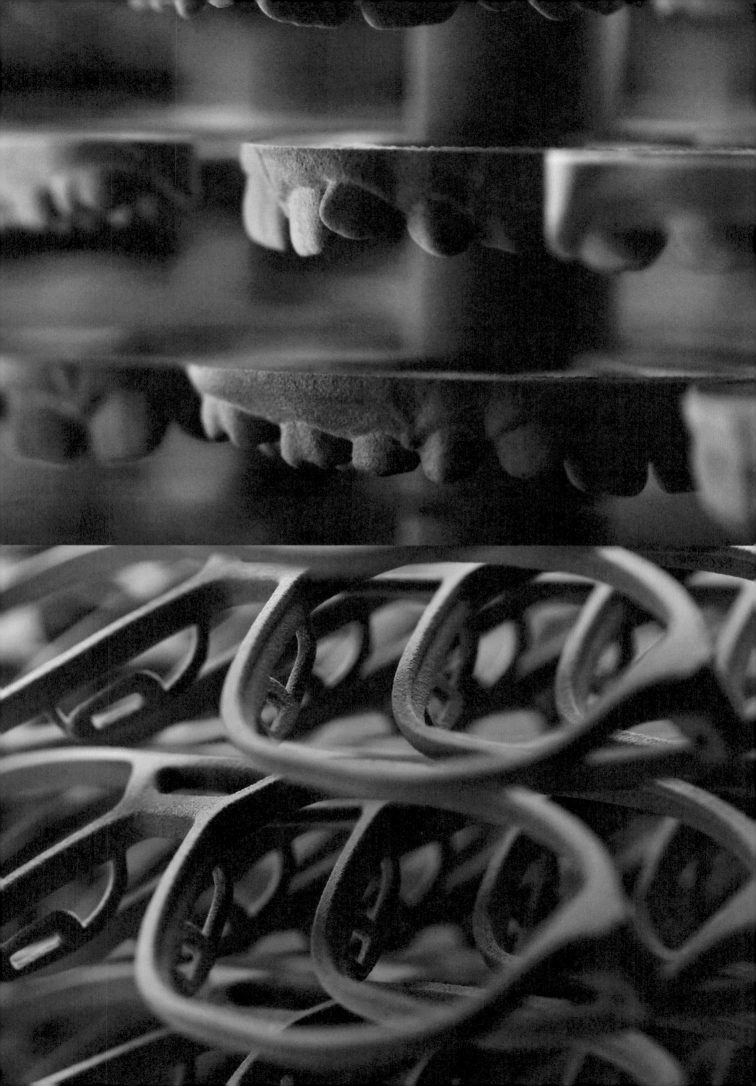

03 HUMAN POTENTIAL

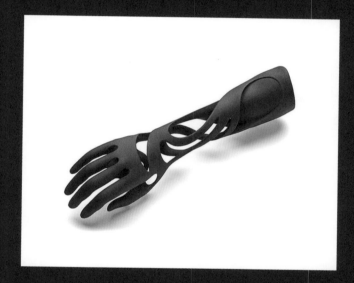

INNOVATIONS ARE, AT THEIR BEST, ABOUT
MAKING LIVES BETTER

IT IS UP TO TECHNOLOGY COMPANIES LIKE
HP TO INVENT TOOLS THAT ENABLE
CREATORS TO BRING THEIR IDEAS INTO THE
REAL WORLD.

HP 3D PRINTERS EXPAND PROTOTYPING AND MASS
PRODUCTION CAPABILITIES ACROSS INDUSTRIES

04

WORKING TO IMPROVE PERFORMANCE IS A NEVER-ENDING JOB.

David Packard

TECHNOLOGY FOR ALL

04 Technology For All

The Impetus for Iteration

Technological breakthroughs that impact our everyday lives – they usually begin as costly R&D efforts by companies that are willing and able to make the bold bets. As a result, the first commercial products can be prohibitively expensive, accessible only to large businesses that can afford the cutting edge. HP breakthrough products were no exception: at launch, they were often accessible to only a small segment. But on the heels of these early successes, HP's commitment to rapid iteration was fueled by a belief in technology for all. Within a short period of time, products that were initially out of reach for all but a few became affordable for most – and not by making them less powerful, with fewer features. At HP, the commitment has always been simultaneously more affordable **and** better.

EXOTHERMIC INITIATIVE

From Desktop to Shirt Pocket

HP's entry into the calculator market, which now seems like a natural extension of its focus on scientific measurement, was in fact influenced by serendipity. Packard had decided to stay out of the calculator business until, in an idea from a young engineer, he saw the seeds of a product that could make noisy mechanical calculators obsolete. This was in alignment with a key corporate objective: "to enter new fields only when the ideas we have, together with our technical, manufacturing and marketing skills, assure that we can make a needed and profitable contribution to the field." To that end, HP's decades of calculator innovation are an iconic part of its storied history.

Inventor and electronics designer Tom Osborne had been rejected by multiple companies when he demonstrated his balsa wood "Green Machine" (nicknamed for its Cadillac Green Metallic paint job) to HP in 1965. His ideas about more efficient ways to design digital circuits contributed greatly to the development of the 9100A, one of the most important inventions in HP's history. It was not only their first calculator – it was the first commercially available programmable desktop calculator.

TOM OSBORNE, THE MAN WHO BROUGHT CALCULATORS TO HP

It was HP's meritocratic, team-based approach to innovation that set the stage for the integration of Osborne's ideas (and Osborne himself) into a hothouse of inventiveness that culminated in the 9100A. Its development was a convergence, what HP Labs head Barney Oliver later called "exothermic":

" . . . when the proper ingredients are brought together the reaction starts automatically and it is only necessary to harness and control the power that is generated. The 9100A project was one of the most exothermic I have known."[30]

Believing that the best results come when you put the right people together and let them work, the team that was assembled went from the prototyping stage to a pilot run of final instruments in only ten months.

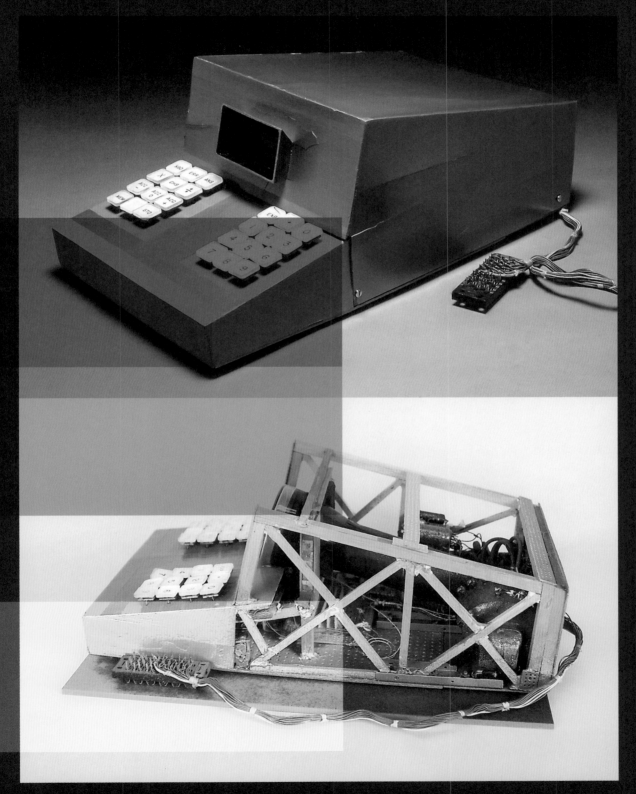

EARLY PROTOTYPES OF WHAT WOULD BECOME THE 9100A

The resulting product made waves. Read-only memory (ROM) was still a new technology; its use in the 9100A sparked desktop calculator development throughout the tech industry and helped set the stage for the computer revolution. Its sleek look was so futuristic that it was frequently used as a movie prop, and would later be echoed in the design of Apple's first successful product, the Apple II home computer. Arthur C. Clarke, the science-fiction writer behind *2001: A Space Odyssey*, remarked in a magazine that his most-desired Christmas gift that year was a 9100A; the quote found its way to Barney Oliver, and one arrived the following January bearing an engraved plaque from "his many admirers at Hewlett-Packard."

Initially priced at $4900, the 9100A cost nearly twice as much as a new car in 1968. But with its breakthrough technology and format, it outpaced all HP's hopes and in short order became one of their top-selling products, averaging 200 units per month. But even amidst the excitement of such an accomplishment, Bill Hewlett was already thinking about the next step.

"At the introduction of the HP 9100 at the IEEE show . . . in March of 1968, Bill Hewlett, Barney Oliver and I gave a private showing to An Wang. Wang Laboratories had one of the best calculators on the market and the HP 9100 was obviously going to seriously affect their position.

Dr. Wang's parting words were, 'You have a good machine. We had better get busy.' After he had gone, Bill Hewlett said, 'I think the next machine should be a tenth the cost, a tenth the size, and be ten times faster than the HP 9100.'"[31]

TOM OSBORNE

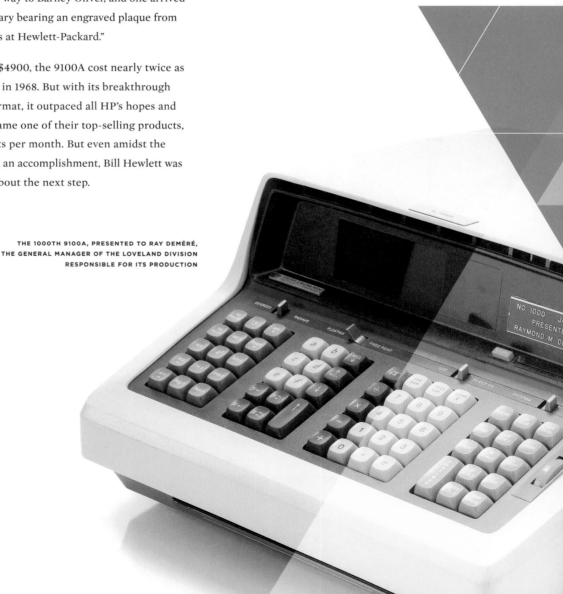

THE 1000TH 9100A, PRESENTED TO RAY DEMÉRÉ,
THE GENERAL MANAGER OF THE LOVELAND DIVISION
RESPONSIBLE FOR ITS PRODUCTION

SETTING THE STAGE FOR THE COMPUTER REVOLUTION

ROY OZAKI SHAPING THE FIRST ROUGH CLAY
MODEL OF THE HP 9100A WITH MODELING TOOLS
AND CARDBOARD TEMPLATES

A SHARED VISION OF WHAT IS POSSIBLE

Though the world likes tales of the solitary genius or the iconoclastic inventor, real innovation as practiced at HP has always been a joint effort, requiring a keen eye for talent, a culture of collaboration, and a shared vision of what is possible. The contributors to the design and development of the 9100A were an all-star team of engineers, each responsible for a critical component of the end product:

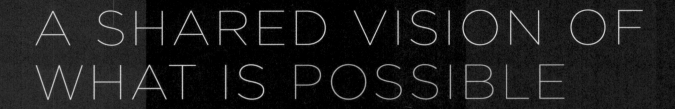

HP 9100A TEAM & CONTRIBUTORS

+ JACK VOLDER'S CORDIC ALGORITHM FOR CALCULATING TRIGONOMETRIC FUNCTIONS

+ J. E. MEGGITT'S ALGORITHMS FOR PSEUDO DIVISION AND PSEUDO MULTIPLICATION

+ TOM OSBORNE'S VLIW (VERY LONG INSTRUCTION WORD) FLOATING-POINT PROCESSOR DESIGN, WHICH RESULTED IN A FAST, LOW-POWER FLOATING-POINT CALCULATOR

+ A PRINTED-CIRCUIT BASED, INDUCTIVE READ-ONLY MEMORY DEVELOPED BY HP'S CHUCK NEAR AND ARNIE BERGH

+ CHUNG TUNG'S ADAPTATION OF MINICOMPUTER CORE MEMORY TO THE LIMITED STORAGE NEEDS OF A DESKTOP CALCULATOR

+ HIGHLY NESTED VLIW PROGRAMMING BY DAVE COCHRAN AND TONY LUKES

+ ROY OZAKI'S AND DON AUPPERLE'S FUTURISTIC INDUSTRIAL STYLING WHICH WON THE HP 9100A CAMEO APPEARANCES IN VARIOUS MOVIES

HP 9100A
DESKTOP CALCULATOR

THE 9100A WAS BOTH THE WORLD'S FIRST PROGRAMMABLE
DESKTOP CALCULATOR AND THE FIRST COMMERCIAL
SCIENTIFIC CALCULATOR

DESIGNED WITH YOU, THE USER, IN MIND

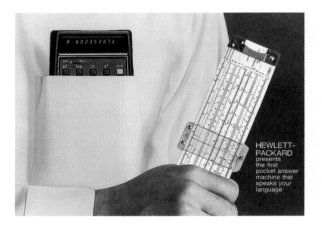

A 1972 BROCHURE FOR THE HP-35 COMPARED IT TO THE
SLIDE RULE IT QUICKLY RENDERED OBSOLETE

The drive to top the success of the 9100 gave rise to the HP-35, the infamous killer of the slide rule. It was both a classic example of the next bench phenomenon (*see Chapter 2*), and an effort to start democratizing technology that had previously been available only to a scientific audience.

"Our object in developing the HP-35 was to give you a high precision portable electronic slide rule. We thought you'd like to have something only fictional heroes like James Bond, Walter Mitty or Dick Tracy are supposed to own . . .

The HP-35 was designed with you, the user, in mind. We spent as much time on the keyboard layout, on the choice of functions, and on the styling as we did on the electronics."

FROM THE HP-35 MANUAL

It turned out to also be an opportunity for HP to demonstrate its integrity. When the HP-35 was discovered to have a few bugs, it had already sold more than 25,000 units, a huge volume for HP at the time.

"In a meeting, Dave Packard asked what they were going to do about the units already in the field and someone in the crowd said, 'Don't tell?' At this Packard's pencil snapped and he said: 'Who said that? We're going to tell everyone and offer them a replacement. It would be better to never make a dime of profit than to have a product out there with a problem.' It turns out that less than a quarter of the units were returned. Most people preferred to keep their buggy calculator and the notice from HP offering the replacement."[32]

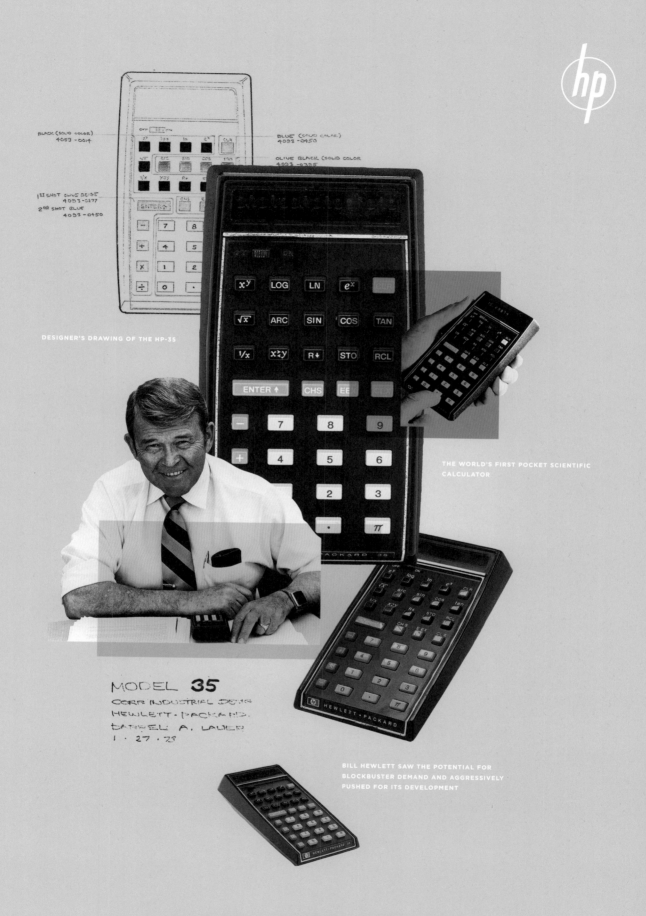

DESIGNER'S DRAWING OF THE HP-35

THE WORLD'S FIRST POCKET SCIENTIFIC CALCULATOR

MODEL 35
CORP INDUSTRIAL DEV
HEWLETT·PACKARD.
DARREL A. LAUER
1 · 27 · 73

BILL HEWLETT SAW THE POTENTIAL FOR BLOCKBUSTER DEMAND AND AGGRESSIVELY PUSHED FOR ITS DEVELOPMENT

HP-35 SCIENTIFIC CALCULATOR

1972

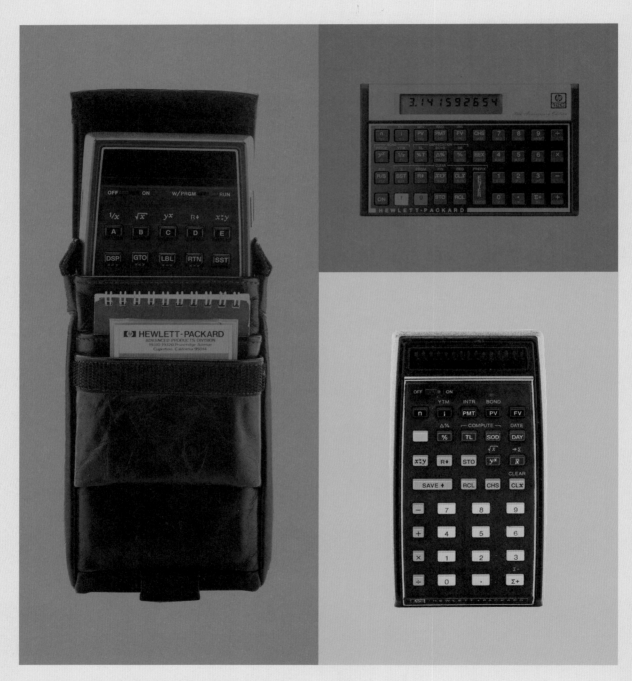

HP CONTINUED TO ITERATE CALCULATORS USEFUL IN MANY FIELDS,
ALWAYS STRIVING FOR MORE POWER IN A SMALLER AND MORE
AFFORDABLE PACKAGE

SMALLER, CHEAPER, AND MORE POWERFUL

1974 AD FOR THE HP-65

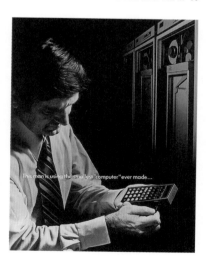

This man is using the smallest "computer" ever made...

Iteration continued in the calculator line. The HP-80 reinvented the HP-35 for business, giving the handheld calculator a much wider audience. The HP-65 was a programmable version of the HP-35, introduced just 18 months later. At $795, it was a fraction of the cost of the 9100 desktop series, which made programming something for the everyday world, in a variety of uses, rather than restricted to institutions with seven-figure equipment budgets. Its ads proclaimed, "This man is holding the smallest programmable computer ever made." Subsequent generations continued to grow ever smaller, cheaper, and more powerful. The HP-12C financial calculator, introduced in 1981 and still in production, remains the company's longest-running consumer product.

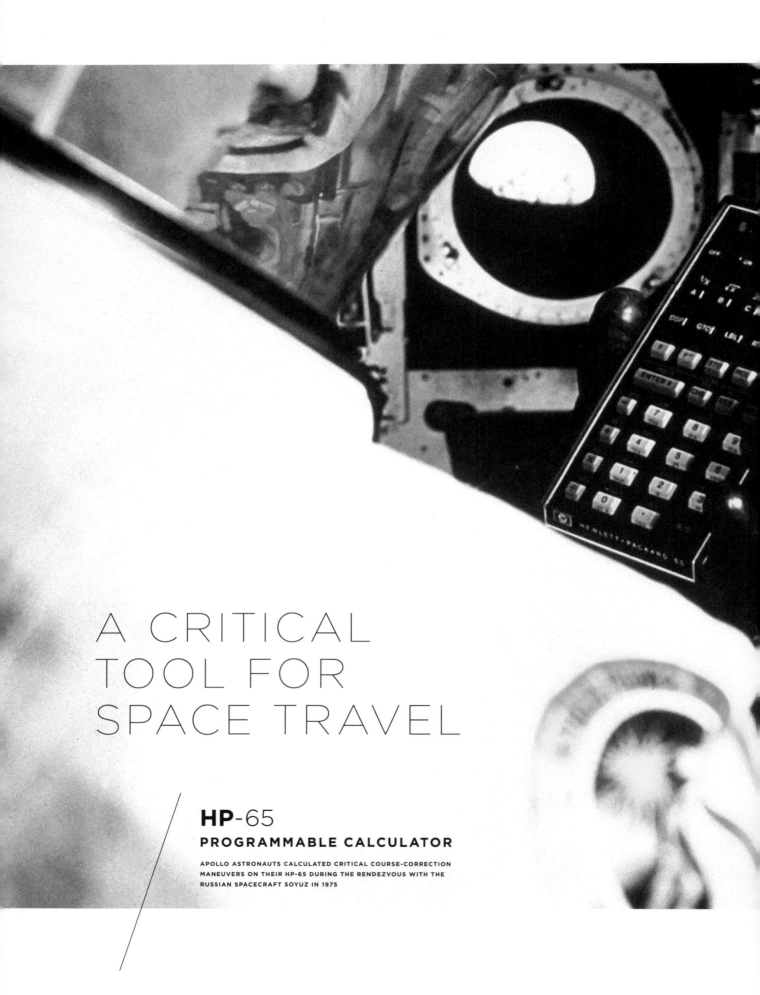

A CRITICAL
TOOL FOR
SPACE TRAVEL

HP-65
PROGRAMMABLE CALCULATOR

APOLLO ASTRONAUTS CALCULATED CRITICAL COURSE-CORRECTION
MANEUVERS ON THEIR HP-65 DURING THE RENDEZVOUS WITH THE
RUSSIAN SPACECRAFT SOYUZ IN 1975

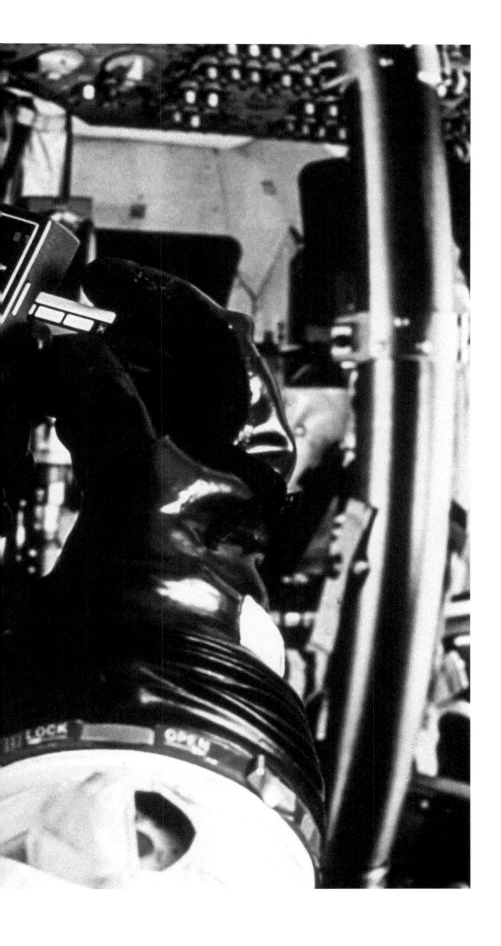

From Instrument Controller to Personal Computer

HP never set out to become a "computer" company. In fact, they had every reason to avoid it; in 1965, IBM was one of HP's largest customers, with a reputation for ruthless competition. It was instead the company's core principles – commitment to innovation, finding the right people and trusting them to find paths to success – that led to its transformation into a computing systems and services powerhouse.

"It would be nice to claim that we foresaw the profound effect of computers on our business and that we prepared ourselves to take early advantage of the computer age . . . It would be more accurate to say that we were pushed into computers by the revolution that was changing electronics."[33]

DAVID PACKARD

That legendary commitment to innovation has never required being first at something, but it does mandate being better, introducing products that add something rather than hopping on any bandwagon. The seminal calculator and computer products introduced in the 1960s each had several "firsts" attached to them, but were overwhelmingly about creating smarter, better products.

THE 2116A, HP'S FIRST COMPUTER, WAS COMBINED
WITH A DATA ACQUISITION SYSTEM TO COMPRISE
THE HP 2018

AN HP EMPLOYEE WORKING WITH THE HP 2116A
CIRCA 1968

The 2116A was not the first computer when it was introduced in 1966; in fact, it wasn't designed and marketed as a standalone computer at all, but as a controller for other HP products. But it made a splash; as one of the world's earliest 16-bit computers, it offered affordable computing power by mid-1960s standards, even with a price tag of $25,000 (nearly $200,000 today).

HP quickly found that it was selling more units to customers opting to use it as a standalone computer than as an instrument controller. In fact, its design for instrumentation was what made it so attractive; computers of the time were very large and notoriously unreliable. Instruments, on the other hand, were used in a far wider variety of environments and conditions. Following HP's high standards for quality, the 2116A was rugged, durable, and far more reliable.

HP 2000A

A PAGE FROM THE 2000A SALES BOOK ILLUSTRATING
SIMULTANEOUS USE

THE TURNING POINT

Following its customers' lead, the company soon introduced the 2000A, a timeshare system supporting up to sixteen users and using the BASIC programming language. It wasn't all smooth sailing; the new machine was taking on IBM, which upper management had largely tried to avoid. Tom Perkins, who would later become the first general manager of the company's computer divisions, recalled:

"Packard . . . was really angry because I hadn't gotten permission to take over the division, or to do this launch. We'd sold about ten of them. They cost $150,000. And the profit margin was about 80 percent. I took out the books and showed Packard. He walked in with his shirtsleeves rolled up above his elbows and chewing his cigarette and he looked at those numbers and he sort of put the shirtsleeves back down, cigarette out. And he said, 'Looks OK.' That was the winning of the war in terms of the computer becoming a freestanding business. That was the turning point, just before he went to the Defense Department."[34]

In 1968, the year both the 9100A and the 2000A were introduced, scientific computing accounted for only about 4 percent of the company's sales.[35] Within 8 years, a whopping sixty percent of HP's sales would involve either scientific instrumentation with computing assistance, or computing systems alone. By 1994, almost $20 billion of HP's sales were in computer products, service and support.

However, becoming a computer company had never been HP's goal. Instead, the company's objective of offering outstanding measurement capabilities led them naturally to computing. The transformation was driven by the company's fundamentals; a combination of listening to its customers, always asking what its technical contribution would be, and a classic case of the next bench phenomenon:

"Our sales kept growing and other parts of the company had begun to use our computers. That became a major internal market – people all over the company were building computers into their systems and their products. We had battles on inter-company pricing, but the computer was becoming an integral part of HP's life, whether we liked it or not."[36]

CARL COTTRELL, HP VICE PRESIDENT / EMPLOYED FROM 1952-1991

PACKARD CONSULTING WITH EMPLOYEES, CA. 1965

GROWTH FROM PROFIT

The 2000A's success brought the young computer division its first significant cash flow and set the stage for a series of ambitious projects. One of them was Project Omega, which would have been the first 32-bit computer, far ahead of its time. The project was ultimately killed, however, due to the same set of principles that has fostered so much innovation: Omega was taking vast engineering resources needed in the company's core businesses. It was also projected to go tens of millions in the negative before it could turn around toward profitability, which was in direct conflict with Packard's "growth from profit" imperative:

> "It clearly represented a departure from HP's basic principles. It was expensive. We would have to take on debt to fund it, and rather than building on existing HP strengths, the project required expertise and capabilities we did not have at the time . . . "[37]

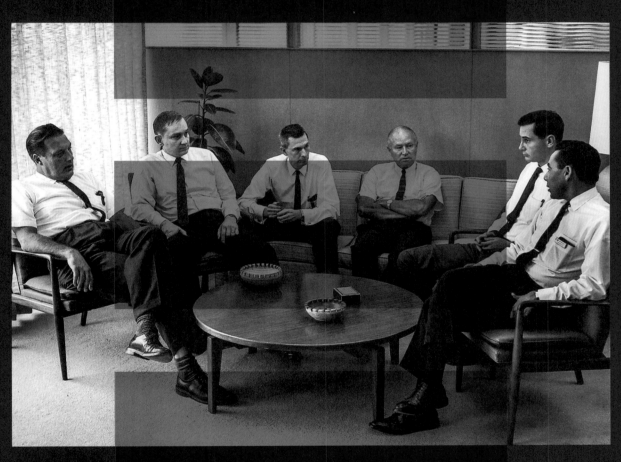

THE ORIGINAL HP LABS MANAGEMENT TEAM: BARNEY
OLIVER, DON HAMMOND, PAUL STOFT, JOHN CAGE,
TOM PERKINS, AND JOHN ATALLA

THE JOURNEY BEGINS

Redubbed "Alpha" – the beginning, rather than the end – the project evolved into the HP 3000, one of the most popular and important products in company history. It was the company's first computer specifically designed as such, and proved to have remarkable reach and longevity, including the distinction of being the first computer installed in the White House. With subsequent updates and supported by best-in-class database management software, the line remained in production for more than 30 years and was honored with "retirement parties" in HP facilities around the globe when it was finally discontinued.

Another result of the 2000A's success – perhaps even more monumental in retrospect – was the start of HP's journey toward peripherals:

"We'd sell somebody a 2100 with a bunch of memory in it for $6,000 to $9,000 and they'd go out and spend $55,000 on terminals. So we finally got a terminal project started. We bought discs from various people, mostly unsuccessfully . . . [We] developed our own tape drive. And we started working on our own small discs. And so we started growing our peripheral group."[38]

BILL TERRY, HP VICE PRESIDENT / EMPLOYED FROM 1957–1993

THE HP 3000 INTRODUCED THE ERA OF
DISTRIBUTED DATA PROCESSING

HP-85 (1980): THIS WAS HP'S FIRST PRODUCT TO BE MARKETED SPECIFICALLY AS A PERSONAL COMPUTER. IT WAS STILL TARGETED TOWARDS ENGINEERS, BUT AT LESS THAN HALF THE PRICE OF THE EXISTING 9825 WORKSTATION. IT WAS PORTABLE AND SELF-CONTAINED, WITH AN INTEGRATED DISPLAY, KEYBOARD AND PRINTER, ACCOMPANIED BY A CARRYING CASE.

HP-110 LAPTOP (1984): AN INDUSTRY BREAKTHROUGH THAT OFFERED PERFORMANCE COMPARABLE TO DESKTOPS. EQUIPPED WITH THE MOST MEMORY AVAILABLE IN A PORTABLE COMPUTER AT THE TIME, IT WAS NONETHELESS AIMED AT LESS TECHNICAL USERS, BROADENING ITS MARKET YET AGAIN.

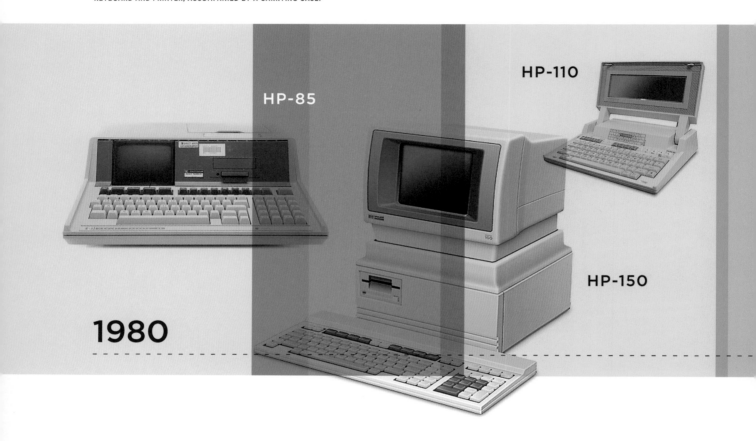

HP-85

HP-110

HP-150

1980

HP-150 (1983): A WATERSHED FOR COMPUTING. ONE OF THE FIRST COMMERCIAL MACHINES TO USE A 3.5" DISK DRIVE, ONE OF THE EARLIEST TO FEATURE A TOUCHSCREEN, AND MARKED THE FIRST TIME HP RAN TV COMMERCIALS FOR A SINGLE PRODUCT.

A BUSINESS TAKING SHAPE

PAVILION LINE (1990S–CURRENT): DESIGNED AND PRICED SPECIFICALLY FOR HOME USE, AND EXCLUSIVELY DISTRIBUTED THROUGH RETAIL CHANNELS, THE PAVILION PC LINE CEMENTED HP'S PLACE AS A CONSUMER TECH COMPANY.

ELITEBOOK LAPTOPS (2000S - CURRENT): ULTRA-SLIM ALUMINUM DESIGNS WITH INDUSTRY-LEADING SECURITY FEATURES.

OMNIBOOK

ELITEBOOK

PAVILION

SPECTRE X360

2021

HP OMNIBOOK 300 (1993): THE SMALLEST AND LIGHTEST PC ON THE MARKET, WITH A FULL-SIZE KEYBOARD AND FULL VGA SCREEN, YET WEIGHING UNDER THREE POUNDS.

SPECTRE X360 CONVERTIBLE (CURRENT): STREAMLINED AND MINIMALIST, A HIGHER-END DESIGN THAN OTHERS IN ITS PRICE CATEGORY.

The drive to make technology widely available, along with a commitment to making a reliable product and then standing behind it, has been demonstrated over and over again as the company's computer business took shape.

A GROUNDBREAKING PLATFORM FOR THE CLASSROOM

HP's democratization of technology culminated in 2004 with the Multi-user 441 desktop solution, a groundbreaking platform for the classroom designed to provide students and teachers in underserved markets with greater access to learning and computer-based training.

"In a world in which more than 90 percent of the population has yet to use technology products, HP recognizes the business potential and market demand to create products that address the needs of developing economies."

HP PRESS RELEASE, JUNE 2004

That commitment continues with multiple entries priced under $500 for students, entrepreneurs, and professionals who work primarily online. Personal systems, including workstations, desktops, and notebooks, have grown into nearly 70% of HP's business. HP continues to listen to its customers, introducing computers at all price points across both consumer and business areas.

CHROMEBOOK DESIGNED FOR STUDENTS AND CLASSROOMS

HP BELIEVES THAT ACCESS TO A QUALITY EDUCATION
IS A FUNDAMENTAL HUMAN RIGHT

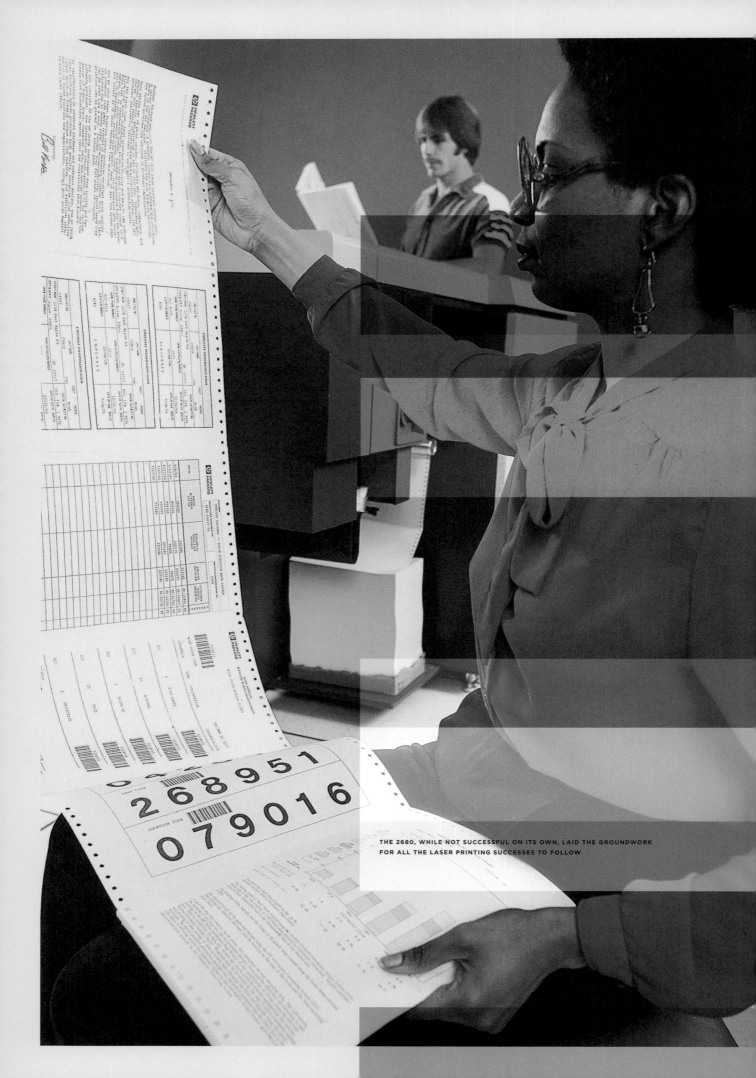

THE 2680, WHILE NOT SUCCESSFUL ON ITS OWN, LAID THE GROUNDWORK
FOR ALL THE LASER PRINTING SUCCESSES TO FOLLOW

MAKING
A MARKET

A Printer in Every Business and Every Home

When HP undertook the journey into peripherals, no one dreamed that printing would account for around 30% of the company's business by 2020. The first lasers, intended for business, certainly didn't set any sales records, especially at an entry point of over $10,000. The eventual runaway success of the DeskJet and the advent of color printing, however, was underpinned by the HP principles at play in those early development days:

+ *Relationship-building, sticking to what the company could do well: The young, hungry Boise division developing the printers had neither the time nor expertise to develop their own print engines. They instead partnered with Canon, a company with similar dedication to integrity, quality, and innovation.*

+ *Business unit independence: The engineers behind the laser printer weren't invested in the thermal inkjet technology being worked on elsewhere in the company. A larger division with established success may not have gambled on what was a then-unproven technology.*

+ *Listening for need: During the intensive development process for the 2680 – in which 35% of the printer's more than 10,000 parts had to be designed from scratch – the engineering team learned the technology inside and out, at the same time internalizing the value customers placed on the ability to mix multiple fonts and graphics on a single page.[39]*

"In early '75 Bill Hewlett called me and said, 'I just met the guys from Canon, and they have a laser printer that you guys should take a look at . . . ' We went to see this thing and it was a great big box – I mean, it was huge, with a liquid toner base that used jet fuel to carry the toner which went on the paper, then you dry it and it catches on fire. And Jim [Hall] said, 'Oh, man, this is going to be a challenge.' We teamed with HP Labs to learn more about it, and they said, 'Well, it is pretty tough' . . . Jim said, 'I love a challenge. We'll take a look at it.' And he came back with this write-up of all these challenges and I thought he was going to say 'No,' but he said 'Let's go get it.'"[40]

RAY SMELEK, HP MANAGER AND VICE PRESIDENT, 1958-1994

It wasn't until 1980 that HP introduced its first laser printer (the 2680A) and in the first three months post-release, zero units were sold. Instead, it was the original LaserJet that transformed the market. Introduced in 1984 – at a fraction of the size and cost (about $3500) of the 2680A – it created a totally new printer market, similar to what the HP-35 handheld calculator had done 12 years earlier. Subsequent versions of the LaserJet were iterations of the "make it cheaper, with even more features" maxim that has long propelled the importance HP places on customer value. Subsequent generations of the LaserJet line printed ever faster, at higher resolution; today, a full-color printer still bearing the LaserJet name can be purchased for around $300. Over the last 25 years, HP is estimated to have sold more than 350 million laser printers worldwide.

$108,500

1980

180 DPI

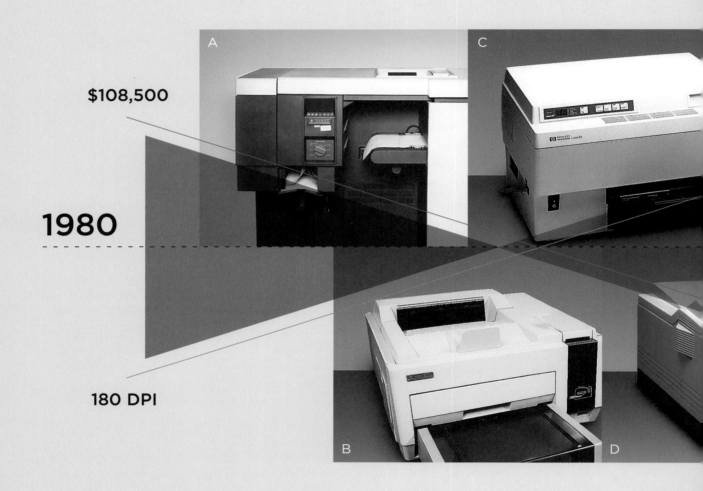

MORE FOR LESS
BECAME THE GOAL
FOR EACH NEW
LASERJET MODEL.

David Packard

600 DPI

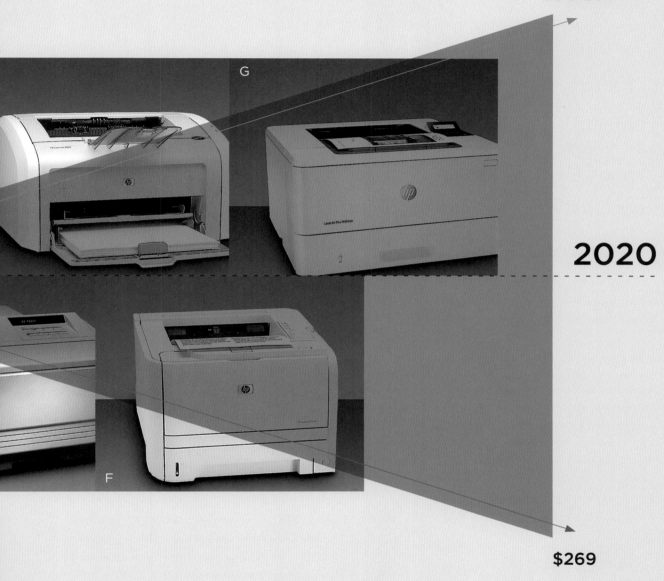

G

2020

F

$269

A HP 2680 / 1980 / $108,500 / 180 DPI
B HP 2688A / 1983 / $29,950 / 300 DPI
C HP LASERJET III / 1990 / $2395 / 300-600 DPI
D HP LASERJET 4V / 1994 / $1999 / 600 DPI

E HP LASERJET 1020 / 2005 / $2199 / 600 DPI
F HP LASERJET P2035 / 2013 / $250 / 600 DPI
G HP LASERJET PRO M404 / 2020 / $269 / 600 DPI

SMALL, LIGHT AND FAST

The LaserJet may have brought high-quality printing to businesses of all sizes – first to the enterprise and, ultimately, to the home office – but it was inkjet technology that truly brought printing to the masses. However, just as with laser printing, it was not an auspicious beginning.

"A lot of people inside HP wanted to kill it . . . At that time, [inkjet printers] were kind of like the early laser printers. They were huge things, with lots of tubes, and they had ink that would run all over everything. They were generally viewed as a royal pain in the neck, but we were particularly intrigued for the desktop . . . because this stuff could be small and light as well as fast."[41]

DUNCAN TERRY, INKJET PROJECT LEADER

The first ThinkJet was launched in 1984. It was only 96 dpi and required a special clay-coated paper. Drying times were lengthy and it wasn't waterproof, so "whole pages vanished when the coffee spilled, and labels ran in the rain."[42] The game changer was the full-color DeskJet 500C, launched in 1992. Priced at $995, it was still out of reach for many homes, but by the end of 1992, HP had sold nearly five million DeskJet printers, almost matching LaserJet cumulative sales. How did HP do it?

"[HP] increased its odds of success by generating many high-variance inventive trials; it mixed and juxtaposed diverse technologies, professions, and experience, managed by objective and collocated. The firm exploited this variance with effective selection processes, strong socialization norms, deep experience with the components of invention, rapid prototyping and testing, and scientific knowledge and method."[43]

LEE FLEMING, HARVARD BUSINESS SCHOOL PROFESSOR, HP ENGINEER 1985-1995

"I'd recommend an HP DeskJet to everyone but my competitors."

"My company lives or dies by the image we project. Not only on the goods we manufacture but on the reports and documents we produce too.

That's why we have Hewlett-Packard DeskJet printers. They're so simple to use even I can manage. The range of printers we have gives us a choice of either just black and white or black and white with colour.

And what printing! The quality is much better than the output most of our competitors produce, thanks to its HP inkjet technology.

As they are used so much it's reassuring to know it's got a 3 year return to HP warranty, and HP's Diamond Edge extended warranty options.

But what surprised me most about the HP DeskJet printers is their price. They are almost suspiciously low. At least that's what I hope my competitors will think."

Find out how the HP DeskJet printer range can help improve your company's image by telephoning 0344 369222.

HP DeskJet.

CIRCLE 34 ON READER SERVICE CARD

 HEWLETT PACKARD

154

UK AD FOR THE DESKJET 500C, WHICH COMPLETELY
RESHAPED THE MARKET FOR COLOR PRINTING

A

THE EVOLUTION OF THE INKJET PRINTER

1984-2020

A LINEAGE OF FASTER, SHARPER, AND MORE
FULL-FEATURED, MATCHED – PRODUCT BY PRODUCT
– WITH A COMMITMENT TO LIGHTER, EASIER TO USE,
AND MORE AFFORDABLE.

G

A	THINKJET / 1984	**G**	DESKJET PORTABLE / 1992
B	QUIETJET / 1986	**H**	OFFICEJET / 1994
C	PAINTJET / 1987	**I**	DESKJET 6540 / 2004
D	DESKJET / 1988	**J**	PHOTOSMART C6380 / 2010
E	DESKJET 500C / 1991	**K**	TANGO / 2018
F	DESKJET 550C / 1992	**L**	DESKJET 2755 / 2020

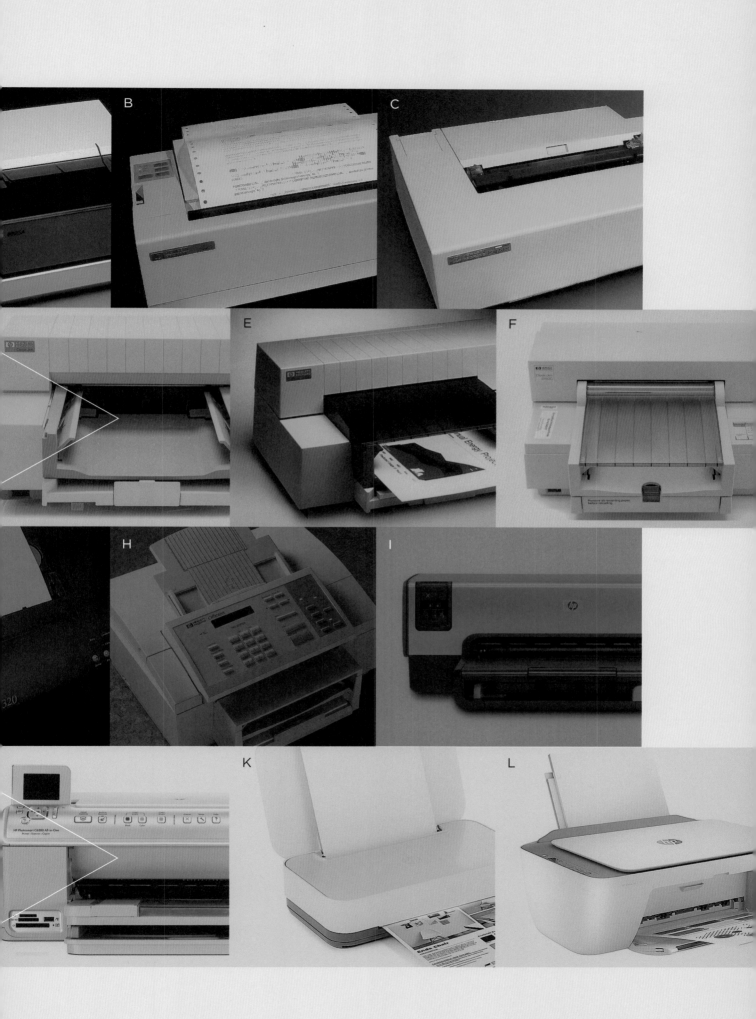

HP PRINTERS PUT QUALITY AND FUNCTIONALITY
IN REACH FOR ALL BUDGETS

REALIZING THE PROMISE OF TECHNOLOGY FOR ALL

Leaps in Quality and Features

The 500C was only the beginning. In the three decades that followed, leaps in quality and features progressed rapidly, and HP was also able to shift profit realization to ink refill purchases – a win-win for the company and for consumers. Today, the HP DeskJet 2755 All-in-One Printer not only delivers exceptional print quality at high speeds, but also functions as a full-featured scanner and copier. The price: $74.99.

HP is estimated to have sold more than 750 million inkjet printers over the last 25 years. And though HP inkjet technology has also evolved to deliver exceptional value for business and commercial applications, it is in products like the DeskJet 2755 that HP has most profoundly realized the promise of "technology for all" in every corner of the world.

HP DESKJET 2755
ALL-IN-ONE PRINTER & APP

THE HP SMART APP PUTS PRINTING, SCANNING, AND DEVICE MANAGEMENT IN THE PALM OF YOUR HAND

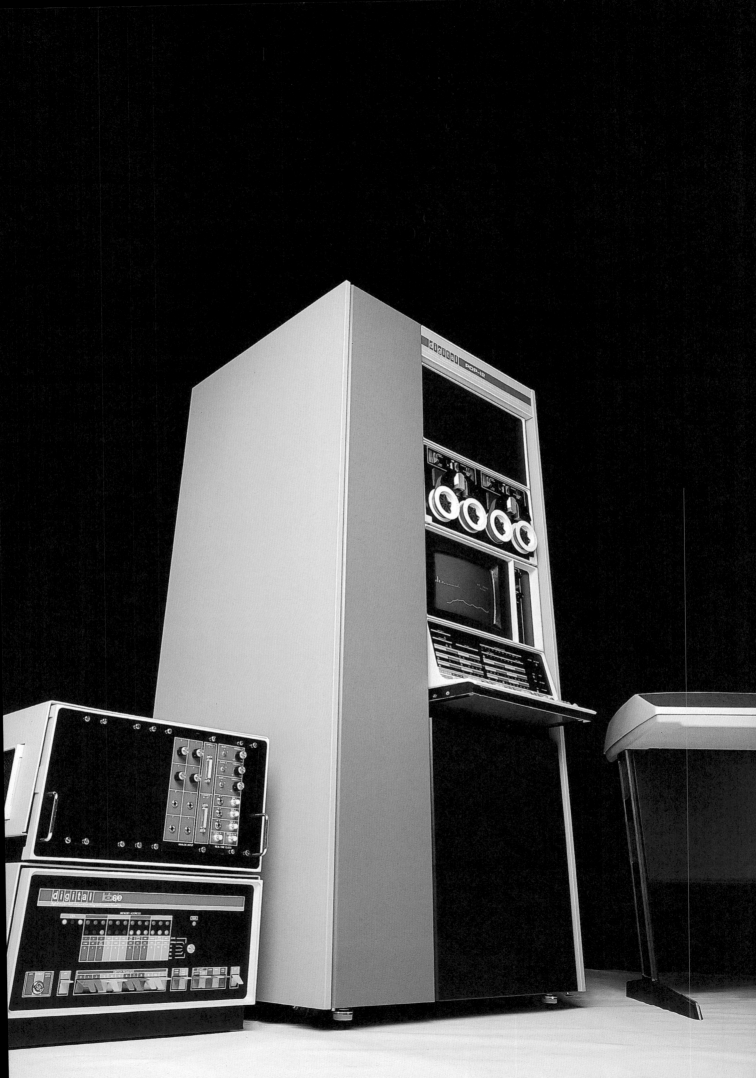

**HP'S DESIGNJET PLOTTERS ARE DESIGNED WITH
BUDGET AND SUSTAINABILITY IN MIND**

HP'S RAPID ITERATION IS FUELED BY A
BELIEF IN TECHNOLOGY FOR ALL. AT HP,
THE COMMITMENT HAS ALWAYS BEEN
SIMULTANEOUSLY MORE AFFORDABLE
AND BETTER.

THE SIZE AND COST OF EARLY COMPUTING MACHINES
MADE THEM USEFUL ONLY TO SPECIALIZED GROUPS

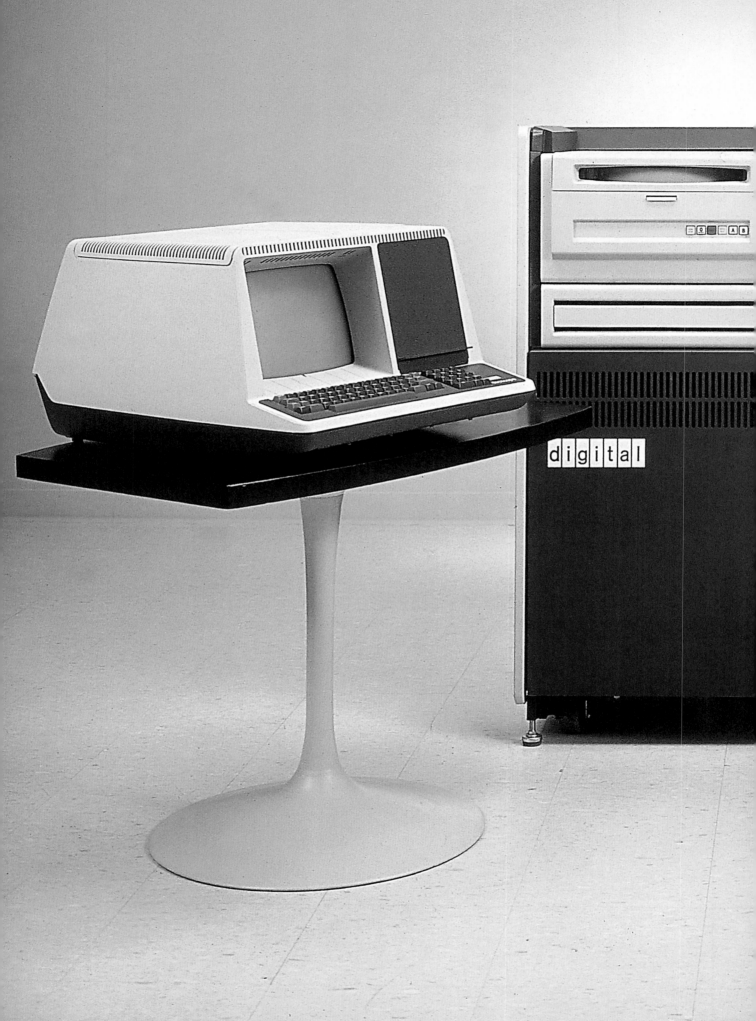

digital

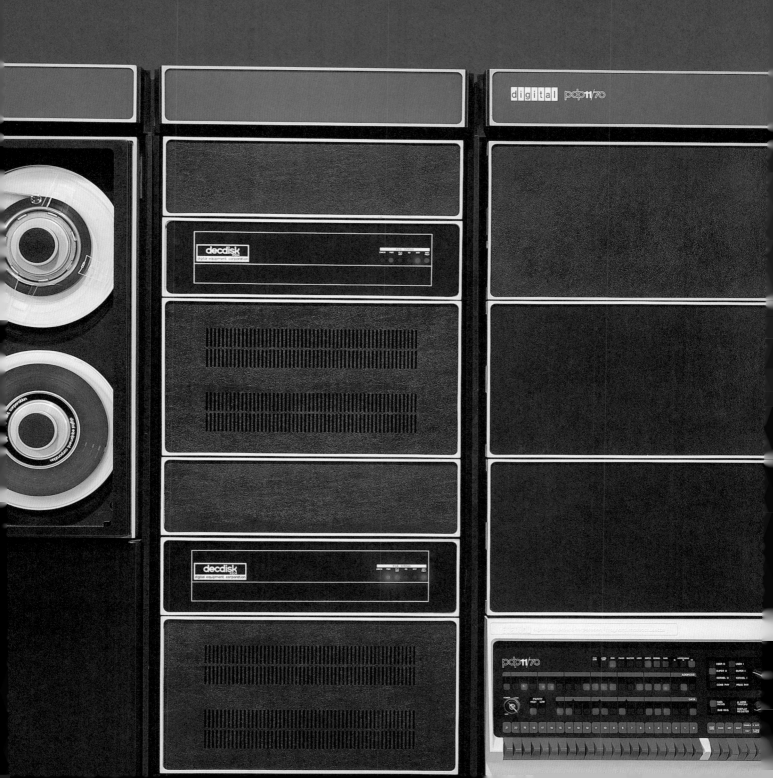

THE BETTERMENT OF OUR SOCIETY IS NOT A JOB TO BE LEFT TO A FEW; IT IS A RESPONSIBILITY TO BE SHARED BY ALL.

David Packard

A GREATER RESPONSIBILITY

05 A Greater Responsibility

People, Planet, Community

What is the role of business in the 21st century and beyond? As the world confronts profound challenges – climate change, wealth stratification, global pandemics; as well as profound opportunities – AI, quantum computing, nanotechnologies; it's no longer enough to manufacture new products that drive business growth. It's not enough, even, to invent new products that continue to contribute to human advancement and scientific achievement. A business's responsibility must be expansive, penetrating, constantly seeking new areas of impact – supply chain, manufacturing, packaging and delivery. In each, ethical imperatives. In each, opportunities for continuous improvement. And for HP: in each, a commitment to the planet, to people, to community.

A deep sense of responsibility was baked into HP's values from the very beginning. Even before Hewlett and Packard decided what to produce, they felt it had to contribute something new or make something better. That philosophy extends to the company's stances on the environment, on employment, on civic involvement, from the highest levels to the most everyday of decisions. It is why HP appears on dozens of lists for the world's most ethical, most environmentally sensitive, and most diverse companies.

"I coined what I call the four 'musts' at HP. You <u>must</u> make a profit, you <u>must</u> make that profit by technical contribution, you <u>must</u> work through people to achieve these objectives, and you <u>must</u> put more back into the community than you take out."[44]

BILL HEWLETT

TODAY, HEWLETT-PACKARD OPERATES IN MANY DIFFERENT COMMUNITIES THROUGHOUT THE WORLD. WE STRESS TO OUR PEOPLE THAT EACH OF THESE COMMUNITIES MUST BE BETTER FOR OUR PRESENCE.

David Packard
The HP Way

BILL HEWLETT GRADING CATTLE (TOP) AND DAVE PACKARD
BUILDING ROADS (BOTTOM) AT THEIR SAN FELIPE RANCH

Environment

Both founders were passionate about the outdoors; their common interest sparked and cemented their early friendship, from a junior-year fishing trip in the Sierra Nevada to a two-week Colorado pack trip post-graduation. As their new company grew, they wanted to share the outdoors with their employees. In the early 1950s, HP bought land at Little Basin, about an hour from Palo Alto, adding a large recreation area for picnics and making the rest of the land available year-round to employees and their families for camping (a benefit they would later duplicate in other parts of the world).

In 1954, Bill and Dave became ranchers, purchasing their own land in San Felipe. It was a family refuge, where both sets of kids learned to swim and ride. And it deepened the connection between the men that served them well back at the office:

"By running ranches together – as well as the company – Bill and I developed a unique understanding of each other. This harmony has served us well every single day in running HP."[45]

Over time, the ranch grew to nearly 29,000 acres – roughly the same size as the city of San Francisco. In honor of their love for the land, in 2008 their adult children donated the development rights, in perpetuity, to non-profit land trust the Nature Conservancy – one of the largest private environmental gifts in California history.

1954

THE SAN FELIPE RANCH WAS A REFUGE FOR HEWLETT
AND PACKARD, BOTH PASSIONATE OUTDOORSMEN

SAN FELIPE RANCH

1954

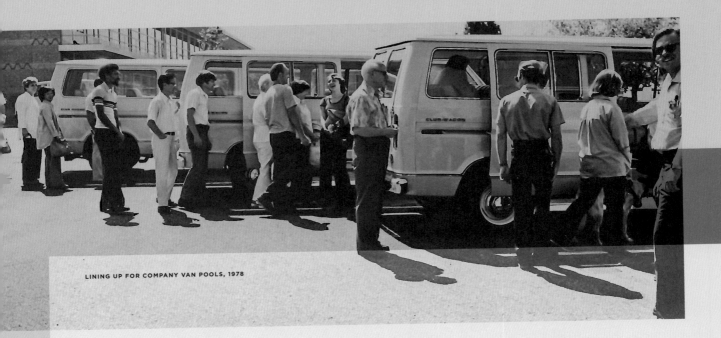

LINING UP FOR COMPANY VAN POOLS, 1978

FUEL CONSERVATION AND ALTERNATIVE TRANSPORTATION

That passion for the planet has been a cornerstone of HP's history. When corporate objectives were updated in 1969, the "Citizenship" section specifically called out a duty to help solve the problems of traffic and pollution. By the mid-1970s, decades before tech buses came to line Bay Area streets, company-owned vans shuttled employees to encourage fuel conservation, and alternative transportation was encouraged.

Those environmental interests extend through every area of the business. From product design, packaging and life cycle, to facility operations around the world, to partnerships with other organizations working toward a more sustainable future, HP views all decisions through an environmental lens – and good for the planet, it turns out, is also good for business.

IT JUST WORKS

Product and Planet

"The official corporate manual on the subject says that Hewlett Packard efforts to maintain high quality will 'pay, not cost the company.'"[46]

HP'S ENVIRONMENTAL COMMITMENT MEANS PRODUCTS ARE BUILT TO LAST, AND BUILT TO BE REPAIRED

From the beginning, HP's products were built to last, and built to be repaired. A routine quality check for a product was that it withstand a three-foot fall onto concrete. Any part of the HP-35, for example, could be opened up for repair by removing just a handful of screws. When the 100 millionth LaserJet printer shipped in 2006, HP ran "It Just Works," a contest in which customers submitted photos and stories of why they thought their printer had lasted so long. Building solid, reliable machines not only built and burnished HP's reputation; it was an environmentally responsible strategy long before anyone framed it in those terms.

THE WORLD'S MOST SUSTAINABLE PC PORTFOLIO

The current product portfolio looks quite different than when HP introduced the Model 810 Research Chromatograph as a pollution-fighter in the 1960s, but the sentiment has remained the same through the decades. The Design for Environment program, launched in 1992, formalized commitments to energy efficiency, recyclability, and materials innovation at the design stage of all its products.

Today, HP boasts the world's most sustainable PC portfolio, with over 300 products in 19 countries rated EPEAT Gold or Silver by the Green Electronics Council – more than any other company in the IT industry. They continue to set (and meet) ambitious goals for increased use of recycled and ocean-bound plastics, incorporating them across the product chain, often first in their category:

HP ELITEDISPLAY E273D
HP ELITE C1030 CHROMEBOOK
HP ELITE DRAGONFLY
HP ZBOOK

MANUFACTURED USING OCEAN-BOUND PLASTIC

MORE
SUSTAINABILITY
FIRSTS

The Tango Terra printer, introduced in 2019, marked more sustainability firsts: not only was it HP's first product certified as carbon-neutral, it was their first printer to use no plastic packaging at all. The HP Neverstop does away with cartridges altogether, a laser-printer first. One of the EPA's first Energy Star partners, HP is pioneering auto-on/auto-off technology that uses up to 26 times less energy than traditional "sleep" mode.

Packaging, too, continues to evolve, minimizing waste and moving toward renewable fibers. Single-use plastic is being replaced with paper and molded fiber alternatives, backed by the goal of zero deforestation and complete recyclability. Reducing packaging sizes also decreases emissions from transportation.

REDUCING WASTE AND USING MATERIALS
RESPONSIBLY IS AT THE HEART OF HP'S DESIGN
FOR SUSTAINABILITY PROGRAM

HP PLASTIC WASHING LINE FACILITY IN HAITI

Operations

The company has long been at the forefront of recycling initiatives from its earliest-known internal program in 1966 and has only continued to expand, establishing hardware recycling (1987), print cartridge return and recycling (1991), and in 1997 became the first computer manufacturer to operate its own end-to-end recycling facility. In 2008, HP engineers made a breakthrough that used recycled content from returned cartridges to make new ones, moving toward a "closed-loop" manufacturing model. By 2018, that model was diverting more than 1 million bottles per day from landfills. The company has codified its commitment to a circular economy, working to design out waste and recapture products at the end of service for reuse.

HP adopted a basic manufacturing policy to protect the environment in 1972, four years before Congress would even pass the first legislation governing toxic substances. An innovative 1975 program to recover precious metals from plating shop wastewater not only saved money, but sparked company-wide efforts at environmental pollution reduction. In the early 1990s, the company tackled the elimination of CFCs and TCA from its production processes. Within two years, both chemicals had been completely replaced with a water wash system that was not only environmentally friendly, but more effective.

ADVANCING A CIRCULAR AND LOW-CARBON ECONOMY

OVER 4000 SOLAR PANELS COVER THE ROOFTOP
OF THE PALO ALTO HEADQUARTERS

Renewable energy, too, has been a priority since HP teams designed and installed a solar heating system at the Sunnyvale facility in 1975. In 2019, HP built Palo Alto's largest commercial solar project; all available roof space at the company's headquarters is solar-covered, generating 1.4 megawatts of solar electricity and offsetting the equivalent of over 1.9 million pounds of coal yearly. Already, HP uses 100% renewable electricity to power operations in the US, with a goal for 100% global renewable power usage by 2035.[47]

Far from greenwashing, HP's environmental commitments are backed up by leadership in transparency. They were among the first global companies to publish its complete carbon footprint, its complete water footprint, and the names and locations of its recycling partners. For its activism and credibility, HP is consistently ranked among the top companies in the world on scores of environmental lists.

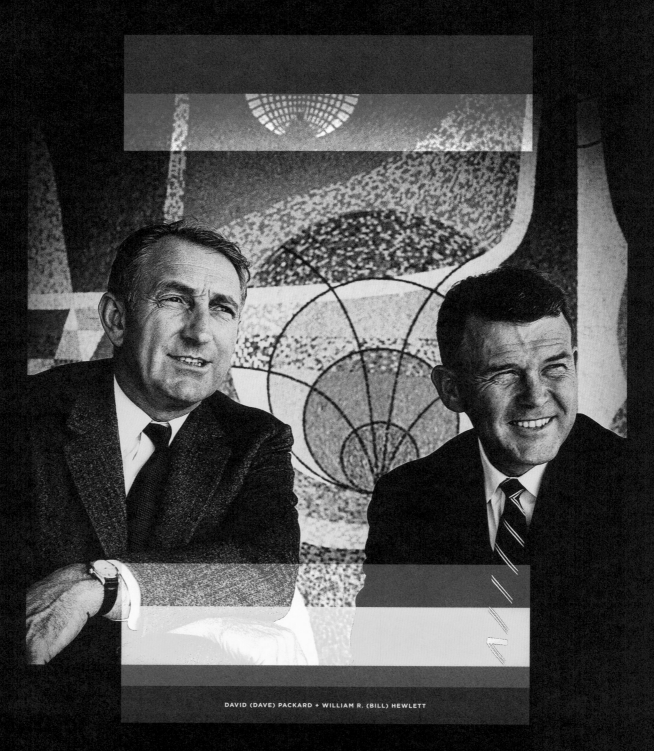

DAVID (DAVE) PACKARD + WILLIAM R. (BILL) HEWLETT

CO-FOUNDERS OF HEWLETT-PACKARD COMPANY

1961

REDEFINING MANAGEMENT

People

"It has always been important to Bill and me to create an environment in which people have the chance to be their best, to realize their potential, and to be recognized for their achievements. Each person in our company is important, and every job is important."[48]

The word "family" appears frequently in discussions about early HP culture. Lucile Packard sent employees wedding and baby gifts to mark major milestones for over a decade. Company picnics were a staple of the annual calendar, with employees doing much of the planning and senior executives doing the serving, the better to get to know the families. HP's commitment to its people, from the beginning, has been built on the underlying principle of sharing – sharing responsibilities, sharing ownership, sharing in profits when things are good, and sharing the burden when they aren't.

1940S COMPANY PICNIC; CONNECTING ON A PERSONAL LEVEL WITH EMPLOYEES WAS OF UTMOST IMPORTANCE TO THE FOUNDERS

Bill and Dave broke with conventional wisdom on management from the first. While many of their initiatives are now considered corporate best practices – especially in Silicon Valley – they were highly unusual in the 1940s and '50s. Employee bonuses quickly evolved into profit-sharing across the company. A major impetus for the company going public in 1957 was to increase employee ownership. Teamwork and egalitarianism were the foundations of HP's famous "Management by Objective" philosophy; the company does its best work if everyone shares common goals, has a stake in the rewards, and feels a part of something larger than themselves.

A CLOSER
CONNECTION
WITH EMPLOYEES

COMPANY PICNIC SOFTBALL GAME, 1949

BILL HEWLETT, 1963

They also believed this commitment was a two-way street. When tuberculosis struck an employee in the 1940s and rendered him unable to work, HP not only helped his family financially, it established a company-wide catastrophic insurance plan so that all employees would have protection, a benefit almost unheard-of at the time. In 1972 HP became the first American company to introduce flextime, initiated at its German plant five years earlier; they regarded it as the essence of respect for and trust in its people, a natural extension of the HP Way.

" . . . it is important to remember that both Dave and I were products of the Great Depression. We had observed its effects on all sides, and it could not help but influence our decisions on how a company should be run. . . . we did not want to run a hire-and-fire operation, but rather a company built on a loyal and dedicated work force. Further, we felt that this work force should be able to share to some extent in the progress of the company."[49]

BILL HEWLETT

In bad times, too, a commitment to teamwork was key. Hit by recession in 1970, the company introduced the "nine-day fortnight" – a 10% pay cut and every other Friday off that applied to employees at all levels. Six months later, when orders were rebounding, everyone was returned to full-time status, with the company's deepest thanks for everyone's sacrifice in helping to keep their colleagues employed at a time it would have been exceptionally difficult to find work elsewhere.

INTERNAL BROCHURE ON FLEXTIME, 1974

WE DID NOT
WANT TO RUN A
HIRE-AND-FIRE
OPERATION,
BUT RATHER
A COMPANY BUILT
ON A LOYAL AND
DEDICATED
WORK FORCE.

Bill Hewlett
The Human Side of Management

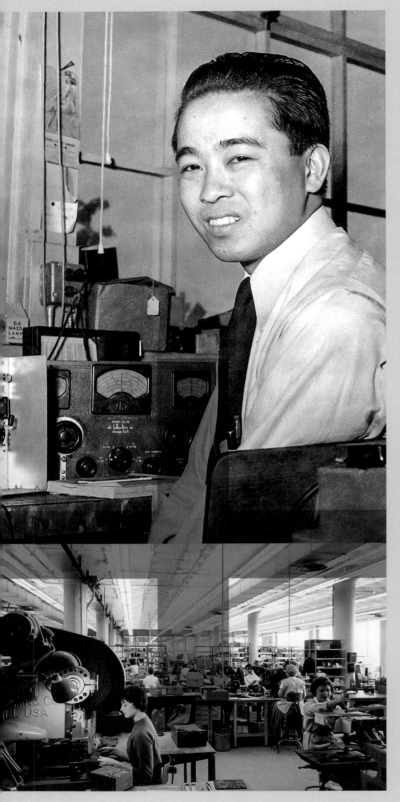

HP BROKE BARRIERS FROM THE BEGINNING WITH
A NONDISCRIMINATION POLICY

SETTING THE TONE FOR DIVERSITY

That sense of egalitarianism continued through HP's employment practices:

"For as long as there has been a Hewlett-Packard Company we have had a nondiscrimination policy applying to hiring, as well as to any subsequent personnel actions relating to employees. We enforce this policy not only because it is good business, but also because it is our responsibility as citizens."[50]

At first informal, but present from the company's inception, HP's position helped set the tone for diversity throughout Silicon Valley. Women were employed not only for secretarial and office positions, but on the production lines and in the labs. The company's first Black employees were hired within just a few years of its founding. In 1946 they hired Art Fong, the first known Asian American engineer in Silicon Valley, who would become an engineering legend as "The Father of Microwave" and eventually rise to vice president.

HP codified their nondiscrimination policy in 1964, wanting to make explicit what had already been long-standing practice amidst the tumult of the civil rights movement. Within several years, the policy had shifted to one of actively improving minority representation. A look back through the company's internal communications throughout the 1960s and '70s show repeated discussions and commitments to equitable hiring, job training, and equal treatment of employees at every level. From 1973 to 1978, women in management and professional roles more than quintupled; minority representation at the same levels tripled.

Today, HP's Board of Directors is the most diverse of any US technology company. Initiatives for inclusiveness and diversity continue not only at every level inside the company, but extend to suppliers, marketing agencies, legal partners, and other groups that do business with HP.

The company conducted its first corporate-wide human rights assessment in 2010, establishing a Human Rights office a year later. They were the first IT company to establish a standard that required suppliers to directly employ their foreign migrant workers. In 2020, the company issued its first Human Rights Progress Report, detailing efforts both inside the company and throughout the supply chain.

BY THE 1960S, EMPHASIS MOVED TOWARD
INITIATIVES FOR INCLUSIVENESS AT ALL LEVELS

MEETING THE
OBLIGATIONS OF
GOOD CITIZENSHIP

Community

A tradition of community involvement started early, with Hewlett and Packard both eager to give back to the communities giving them so much. Both men's service to their country is well-known: in the Army, in Washington, on a variety of advisory commissions and panels. But government posts and military service are just high-profile examples of citizenship, as spelled out in the company's first set of corporate objectives adopted in 1957:

"To meet the obligations of good citizenship by making contributions to the community and to the institutions in our society which generate the environment in which we operate."

Bill and Dave nurtured many community relationships in Palo Alto and in Silicon Valley, first and foremost with Stanford University. Bill had practically grown up on Stanford's campus; he had been only three years old when his father took a job there. It was at Stanford that the men met and were mentored by Frederick Terman, who connected them with the right people and opportunities to get their company underway. HP was an early tenant of the Stanford Industrial Park (now the Stanford Research Park), and were early cheerleaders of bringing technology companies together in one place. Both men donated considerable amounts to Stanford, as evidenced by the William R. Hewlett Teaching Center and the David Packard Electrical Engineering Building. Hewlett was first elected to the Stanford Board of Trustees in 1963, and a note on the Stanford School of Engineering website notes that "His service to Stanford was surpassed only by Leland and Jane Stanford themselves."

PACKARD AND HEWLETT WITH THEIR STANFORD MENTOR FRED TERMAN AT THE HEWLETT-PACKARD WING OF STANFORD'S ELECTRONICS RESEARCH LABORATORY, 1952

THE WILLIAM R. HEWLETT TEACHING CENTER AND THE
DAVID PACKARD ELECTRICAL ENGINEERING BUILDING

VOLUNTEERISM AND CHARITABLE GIVING BY EMPLOYEES IS EXPLICITLY ENCOURAGED

The company's first charitable giving, $5 recorded in 1940, went to a local organization that was a forerunner of Silicon Valley United Way. HP's long relationship with United Way continues to support its work with resources and volunteers. But it goes well beyond one organization. Volunteerism and charitable giving by employees is explicitly encouraged – especially in education, the environment, disaster recovery, and inclusion – with paid volunteer time and regular internal campaigns.

Efforts in education are natural extensions of HP's focus and resources. The level of scholarship programs and school equipment donations led the Public Management Institute to single out HP as "the most generous corporation in the world" in 1990. This focus on educational development gave rise to the HP LIFE initiative, which provides courses in core business and IT skills for free to students and entrepreneurs, both online and through dedicated centers in Mexico, South Africa, and elsewhere around the world. Imagine Grants put resources directly into the hands of organizations bringing technology education to underrepresented communities worldwide.

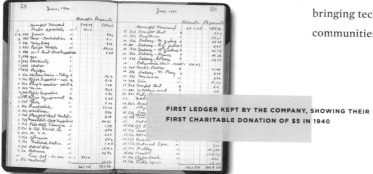

FIRST LEDGER KEPT BY THE COMPANY, SHOWING THEIR
FIRST CHARITABLE DONATION OF $5 IN 1940

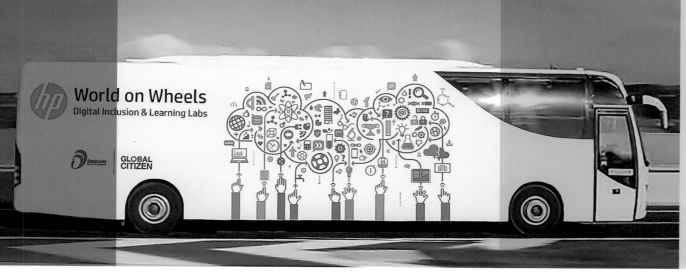

BRINGING TECHNOLOGY AND OPPORTUNITY TO UNDERSERVED COMMUNITIES WORLDWIDE

HP WORLD ON WHEELS

MOBILE DIGITAL INCLUSION & LEARNING LAB

SUPPORTING DIGITAL LITERACY, EDUCATION, AND ENTREPRENEURSHIP
IN RURAL AREAS OF INDIA

HP PROVIDES FINANCIAL SUPPORT, VOLUNTEERS, AND TECHNOLOGY
TO COMMUNITIES AROUND THE WORLD AFFECTED BY DISASTER

MEETING CRITICAL NEEDS AT DIFFICULT TIMES

A Key Focus of Community Contribution

Disaster relief has long been another key focus for community contribution. As a global company, events all over the world have a direct connection to HP and its people. From earthquakes in Central America to wildfires close to home, the company has sponsored drives and sent resources and volunteers to help meet critical needs at difficult times. Putting their unique set of resources to work, HP Connection Spot trailers provide emergency connectivity at disaster sites in the US for people who need to communicate with loved ones, file insurance claims, and start the long process of putting their lives back together.

CONNECTION SPOTS ARE DEPLOYED ACROSS THE US TO HELP DISASTER VICTIMS AND RELIEF EFFORTS

Reinventing Industries, Reinventing Work

From the beginning, "making a contribution to society" has been an idea core to the HP Way. It inspired the earliest electronic measuring instruments; it underlay the breakthroughs in echocardiography; it fueled the development of the atomic clock. Through it all, HP was a pioneer of environmental stewardship, giving back to the community, and an early champion of a diverse workforce with equitable opportunities for all. Taken together, HP's efforts in responsible corporate citizenship made it a paragon of business responsibility that contributed greatly to the arc of 20th century innovation.

But the 21st century holds new challenges – for the planet, and every living thing on it. When it comes to climate change, HP pulls no punches: "Climate change is one of the most significant and urgent issues facing business and society today. The science is clear, the impacts are serious, and the need to act is essential." A company that makes a contribution to society in this era must recognize that the stakes are higher, the scale is greater, and the need for more holistic thinking across industry ecosystems is more profound than ever before.

A circular and low-carbon economy driven by a cradle-to-cradle imperative is absolutely crucial. And HP is at the forefront in its commitment to sustainable sourcing, manufacturing, and waste mitigation. That commitment extends to the millions of HP products that are produced every year.

Still, there is a desire to think bigger, and innovating to reduce the footprint of entire sectors holds the key to that broader impact. It requires deconstructing conventional business models and delivering products that lower the carbon footprint across industry ecosystems.

"Let's take, for example, healthcare. If I had a microfluidics-based system with which I could do complete therapy and diagnostics at home, I wouldn't need to get in the car and go to the hospital for laboratory tests. This would not only be a more expeditious model, but also deliver a net positive impact to the environment given the reduction in the energy footprint."

CHANDRAKANT D. PATEL P.E., HP CHIEF ENGINEER AND SENIOR FELLOW

PLASTIC FROM USED PRODUCTS SHREDDED FOR RECYCLING AT AN HP FACILITY IN TENNESSEE

THE NEXT STEP ON THE HORIZON

Launched in 2016, the HP D300e BioPrinter enables automated laboratory dispensing to "print" pharmaceutical samples instead of ink. The Centers for Disease Control & Prevention (CDC) has since used it to perform antimicrobial susceptibility testing for health departments and hospitals across the United States. In 2020, HP delivered D300e BioPrinters, associated supply cassettes, and training – free of charge – to research laboratories in the US and Europe to help accelerate drug and vaccine research to combat COVID-19. Given HP's commitment to "technology for all" and the growth of telemedicine, home-based diagnostics are simply the next step on the horizon.

In the manufacturing sector, 3D printing has the potential to make supply chains 100% efficient by producing only the parts a manufacturer needs, only when they need them. As 3D printing continues to mature and scale, unused inventory – and the labor, shelf space and delivery requirements that accompany it – could become a thing of the past. HP's Metal Jet printers also eliminate the need for tooling, with the potential to streamline production in multiple industries, including automotive.

"A single car consists of six thousand to eight thousand different parts. A big advantage of an additive technology like HP Metal Jet is it allows us to produce many of these parts without first having to build manufacturing tools. By reducing the cycle time for the production of parts, we can realize a higher volume of mass production very quickly."

DR. MARTIN GOEDE, HEAD OF TECHNOLOGY PLANNING AND DEVELOPMENT, VOLKSWAGEN

In publishing, HP's Indigo presses deliver similar efficiencies with on-demand press runs that have the potential to massively reduce waste from unsold books and carbon produced by inefficient relationships between printers, retailers and buyers.

REMOTE WORK'S
NEXT FRONTIER

Finally, when it comes to everyday productivity and the shift to hybrid work, HP laptops, desktops and printers continue to drive enterprise-grade security into the home office. HP Elite PCs, such as the x360, integrate deep learning and neural networks to detect threats, giving employees and corporations the assurances they need to make daily commutes less necessary. VR technologies like HP's Omnicept headset may allow workers to scale their expertise across multiple work sites and assembly lines, increasing productivity while assessing cognitive load to ensure optimal performance.

HP REVERB G2 OMNICEPT EDITION
VIRTUAL REALITY HARDWARE

CAPTURING USER DATA IN REAL TIME TO CREATE INSTANTLY
ADAPTIVE EXPERIENCES

PACKARD ON THE PRODUCTION FLOOR, 1963

An Evolving Criteria for Growth

At HP, an ambition to change the world has always been fundamental. Founded by inventors who rarely saw a challenge they and their teams couldn't tackle, the company continues to explore new technologies that can and will contribute to the realization of human potential. Today, as always, choices of what to take on are based on prudent business principles – not the least of which has been "growth from profit." But at HP, profit has never been isolated from making a contribution to society. In fact, profit and growth have always been seen as proof of the value of HP's contributions – to its customers, certainly, but to society, fundamentally. And as we look to the decades ahead – for HP, for Silicon Valley, for the world – David Packard's words from 1960 seem more prescient than ever.

I THINK MANY PEOPLE ASSUME, WRONGLY, THAT A COMPANY EXISTS SIMPLY TO MAKE MONEY. WHILE THIS IS AN IMPORTANT RESULT OF A COMPANY'S EXISTENCE, WE HAVE TO GO DEEPER AND FIND THE REAL REASONS FOR OUR BEING.

" . . . as we investigate this, we inevitably come to the conclusion that a group of people get together and exist as an institution that we call a company so they are able to accomplish something collectively which they could not accomplish separately. They are able to do something worthwhile – they make a contribution to society."

David Packard

**HP IS INNOVATING WAYS TO CAPTURE AND USE
OCEAN-BOUND PLASTIC**

HP'S VISION IS A WORLD WHERE
TECHNOLOGY DRIVES EXTRAORDINARY
CONTRIBUTIONS TO HUMANITY.

**AN EMPLOYEE AT HP'S RECYCLING WASHING LINE
IN HAITI, OPENED IN 2020**

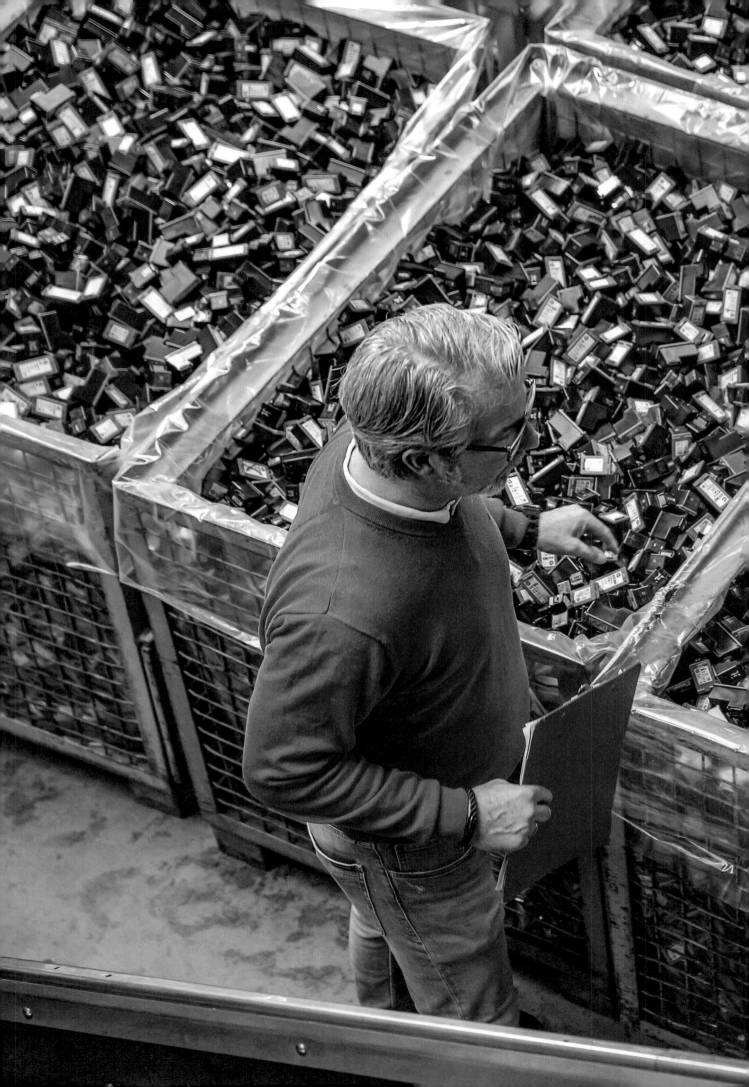

AFTERWORD

THE WAY FORWARD

So much has changed since HP's founding in 1939. The days of manufacturing oscillators are, of course, long gone. The company formed in a small garage has grown into not just one multinational corporation, but at least three (HP Inc., HP Enterprise, Agilent Technologies). When the company went public in 1957, a single HP share was worth $16; today that share would equate to more than 900 shares in six different companies – worth more than $25,000. But it's not just HP that has grown in ways that would have been hard to imagine. Silicon Valley has long since become more than a valley. Its geographic boundaries have expanded up the peninsula to San Francisco's evolving tech nexus and down the peninsula to feed San Jose's growing metropolitan vigor. But Silicon Valley has become more than a place on the map. It has become a global icon of innovation; a symbol of what is possible, what is next; an inspiration for all of us.

So what *is* next? Is it really for all of us, or just some of us? Will it address the urgency of climate change or continue to accelerate the existential risks of global warming? Will the next great startup be a force for good in the world, or will it become a victim of its own success and lose sight of its founding principles? Our understanding of the HP Way – its roots, its evolution, its future – has a seminal part to play in our answers to these questions. Not just because of the products it will inspire, nurture and scale. Not only because of the workforce engagement models it will continue to pilot and prove. But because of its persistence – as a collective belief in what a business is capable of, and of what a business is responsible for.

How we define particular elements of the HP Way are variable and always evolving; not just due to the evolution of HP's business, but because they adapt to the language of each individual's sense of responsibility and possibility, each person's way forward – in business, in their communities, in the world. It may mean an idiosyncratic interpretation of "the garage," a different way of connecting with "the next bench," an extension of the concept of "human potential" into previously unimagined realms. One person's "technology for all" may be another person's "innovation for each." And "a greater responsibility" is open to so many interpretations, it hardly seems right to contain it to a single chapter in a single book.

In actuality, the way forward is really 53,000 ways forward – and that's if we only count HP Inc.'s current employee base. When we count all the lives that HP touches, it is many millions of ways forward. Perhaps more than that still: **a whole world in which technology inspires extraordinary contributions to humanity,** in which **one thoughtful idea has the power to change the world for the better.**

TOP, BILL HEWLETT RAPPELLING ON MOUNT OWEN, CALIFORNIA, 1930;
BOTTOM, DAVE PACKARD DURING FOOTBALL PRACTICE AT STANFORD, 1934

DEDICATED TO

WILLIAM HEWLETT

MAY 20, 1913 – JANUARY 12, 2001

DAVID PACKARD

SEPTEMBER 7, 1912 – MARCH 26, 1996

THE EVOLVING WAY

N O T E S

01	1.	Undated letter from Bill Hewlett to David Packard, 1938. HP internal source.
	2.	Michael S. Malone, *Bill & Dave: How Hewlett and Packard Built the World's Greatest Company* (New York: Portfolio, 2007), p. 189.
	3.	Michael A. Hiltzik, "High-Tech Pioneer William Hewlett Dies," *Los Angeles Times*, January 31, 2001.
	4.	The model 200CD remained in the HP Test & Measurement catalog until 1985.
	5.	Charles H. House and Raymond L. Price, *The HP Phenomenon: Innovation and Business Transformation* (Stanford: Stanford University Press, 2009), chap. 2.
	6.	Applies to HP PCs, Workstations and Displays manufactured after January 2019. Based on most Gold and Silver EPEAT® registrations by meeting all required criteria and achieving 50-74% of the optional points for EPEAT® Silver and 75-100% of the optional points for EPEAT® Gold according to IEEE 1680.1-2018 EPEAT®. Status varies by country. Visit https://www.epeat.net for more information.
	7.	1963 speech, HP internal source.
	8.	ESADE 2017 Award acceptance speech, https://www.esade.edu/en/news/enrique-lores-hp-key-innovation-understand ing-customers-pushing-technology-limit-and-generating-new-imaginative-solutions/15560-333247.
02	9.	David Packard, *The HP Way: How Bill Hewlett and I Built Our Company* (New York: Collins Business Essentials, 2006), p. 97.
	10.	John Minck, *Inside HP: A Narrative History of Hewlett-Packard from 1939-1990* (2011), p. 29. https://www.hpmemoryproject.org/an/pdf/HPNarrative111109.pdf.
	11.	Malone, *Bill & Dave*, p. 189.
	12.	David S. Cochran, *A Quarter Century at HP* (2011), p. 16-17. https://www.hpmemoryproject.org/an/pdf/A_Quarter_Century_at_HP110829.pdf.
	13.	House, *The HP Phenomenon*, chap. 4.
	14.	House, *The HP Phenomenon*, chap. 5.
	15.	House, *The HP Phenomenon*, chap. 5.
	16.	Charles H. House, "The Inside Story of the HP 1300A X-Y Display," 2011. https://www.hpmemoryproject.org/timeline/writings/hp1300a_00.htm.
	17.	Minck, *Inside HP*, p. 51.
	18.	House, *The HP Phenomenon*, Appendix D.
	19.	"6 Questions: One-on-One with Ron McKenzie, CEO, Octopz Inc." *Canadian Business*, September 17, 2008, https://www.canadianbusiness.com/technology-news/6-questions-one-on-one-with-ron-mckenzie-ceo-octopz-inc/.
03	20.	House, *The HP Phenomenon*, chap. 14.
	21.	"The Giant Step," *Measure*, September 1969, p. 5.
	22.	Bill Hewlett, "From the President's Desk," *Measure*, September 1969, p. 15.
	23.	Keith Jarett, "HP 41 in Orbit," *Personal Computing*, October/November 1984, p. 50-54. Excerpt retrieved from http://web.archive.org/web/20000621003759/http://www.nasm.si.edu/nasm/dsh/artifacts/GC-hewlett-.htms

24. "NASA's Day in the Sun," HP case study, October 2020. https://h20195.www2.hp.com/v2/getpdf.aspx/4AA7-9208ENW.pdf.

25. Larry Gordon, "Father Figure," *Stanford Magazine*, March/April 2001. https://stanfordmag.org/contents/father-figure.

26. "Monitoring Modern Surgery," *Measure*, November 1963, p. 3.

27. David Packard, "From Our President's Desk." *Measure*, February 1964, p. 2.

28. "Pollution: HP instruments enter the battle against a problem of growing magnitude," *Measure*, February 1967, p. 9.

29. HP Discover keynote speech, June 2012. Quoted on crn.com: https://www.crn.com/news/cloud/240001533/dreamworks-ceo-hp-has-played-huge-role-in-our-success.htm.

04 30. Bernard M. Oliver, "How the Model 9100A Was Developed," *Hewlett-Packard Journal*, September 1968, p. 20.

31. "Tom Osborne's Story in His Own Words," 1994. http://www.hp9825.com/html/osborne_s_story.html.

32. David G. Hicks, The Museum of HP Calculators: https://www.hpmuseum.org/hp35.htm.

33. Packard, *The HP Way*, p. 101.

34. House, *The HP Phenomenon*, chap. 5.

35. House, *The HP Phenomenon*, chap. 6.

36. House, *The HP Phenomenon*, chap. 6.

37. Packard, *The HP Way*, p. 103.

38. House, *The HP Phenomenon*, chap. 6.

39. Jim Hall, "HP LaserJet – The Early History," p. 3. https://www.hpmemoryproject.org/an/pdf/HP_LaserJet_early_history.pdf.

40. House, *The HP Phenomenon*, chap. 10.

41. House, *The HP Phenomenon*, chap. 10.

42. Sam Lightman, "The Eight-Year, Overnight Success Story," *Measure*, November/December 1992, p. 9.

43. Lee Fleming, "Finding the Organizational Sources of Technological Breakthroughs: The Story of Hewlett-Packard's Thermal Ink-Jet," *Industrial and Corporate Change*, Volume 11, Number 5 (2002): p. 1059–1084.

05 44. Bill Hewlett speech, 1977, HP internal source.

45. Packard, *The HP Way*, p. 70.

46. "HP's Check and Balance System," *Measure*, June 1964, p. 4.

47. "Renewable Energy," 2019 HP Sustainable Impact report, p. 62.

48. Packard, *The HP Way*, p. 62.

49. Bill Hewlett, "The Human Side of Management," *SMECC Vintage Electrics*, Vol. 3 Issue 17.

50. David Packard, "From the Chairman's Desk," *Measure*, July 1968.

IMAGE CREDITS

133 Data courtesy of Invent Medical and NACAR.

134 Orthotic image, data courtesy of Crispin Orthotics.

135 Automotive ventilation system, data courtesy of HP.

135 Buckle, data courtesy of NACAR.

138 Dental aligners, data courtesy of nivellipso.

138 Eyewear, data courtesy of Meidai.

139 Data courtesy of Invent Medical.

142 Data courtesy of Rady Children's Hospital.

04 TECHNOLOGY FOR ALL

149 Images courtesy of the Division of Medicine and Science, National Museum of American History, Smithsonian Institution.

152 9100 from the collection of the Museum of Applied Arts and Sciences. Gift of Hewlett Packard Australia, 1986. Photographer Sotha Bourne.

168 HP 110 image courtesy of The Centre for Computing History, http://www.computinghistory.org.uk/

174 2688A image courtesy of the HP Computer Museum.

177 Courtesy of the HP Computer Museum.

179 QuietJet, PaintJet, and DeskJet Portable images courtesy of the HP Computer Museum.

05 A GREATER RESPONSIBILITY

203 Packaging design and image courtesy of Liquid Agency.

222 Image by Daniel Meigs, courtesy of HP.

223 Well plate image by Jeff Harris, courtesy of HP.

All images not credited here were retrieved from HP's archives or photographed by Tom Maday.

EDITED BY SAM LANDERS & SOL SENDER
BOOK DESIGN BY SCOTT YANZY
TEXT BY SOL SENDER & LINDY SINCLAIR
ARCHIVAL SUPPORT BY HERITAGE WERKS

LCCN: 2021946375
ISBN: 978-1-9519630-8-8

PRINTED AND BOUND IN CHINA
FIRST PRINTING, 2022

INFORMATION:

FOR ADDITIONAL INFORMATION
ABOUT TROPE PUBLISHING CO.,
VISIT TROPE.COM